Improv Shaman

The transformative journey of Divine play

KELI SEMELSBERGER

BALBOA.PRESS

A DIVISION OF HAY HOUSE

Balboa Press books may be ordered through booksellers or by contacting:

Balboa Press
A Division of Hay House
1663 Liberty Drive
Bloomington, IN 47403
www.balboapress.com
844-682-1282

Print information available on the last page.

ISBN: 978-1-9822-6859-6 (sc)
ISBN: 978-1-9822-6860-2 (e)

Balboa Press rev. date: 11/17/2021

CONTENTS

FOREWORD

TO PLAY IS A DIVINE right of being human. It's how we learn, it's how we grow, it's how we keep our spirits alive and not bitter. Play is both an internal and external activity. Just like laughter can help heal, play can help rejuvenate.

Viola Spolin is the mother and source of modern improvisation. In the 1930's and 1940's she invented and implemented 200 improv games for use with immigrant children and children of poverty at Chicago's Hull House. Those 200 improv games are like the table of elements for all improvisation, artistic, educational, and entertainment, that have sprung into existence since. Yet, the main focus of these games, of all improvisation is transformation through play.

Shamanism, like art, like creativity, like therapy, is an internal journey made external through ritual. It's like religion, but older and deeper. Somewhere inside all of us, is this eternal calling to honor and celebrate the stages and phases of our lives; to heal which has been broken through the process of living, gaining, and losing.

I first heard about shamanism from Del Close when I was studying improv from him. Del, though now a controversial figure, was an actor, a beatnik, a comic, a director, a hippie, an improviser, a teacher, and a witch. I'd never heard of shamanism before my classes with Del. He wanted improvisers to become urban shaman acting out the hopes and dreams and nightmares of society and play them back to society.

After Del's class, I started hearing the word "shamanic" used a lot to describe certain artists of different artistic disciplines, but it always felt like the word was being used as an adjective and not as a noun. The only person I saw talk about shaman as a noun was Joseph Campbell in his TV show with Bill Moyers, and it further intrigued me.

So, I investigated it further by reading Michael Harner's book on shamanism and began to understand it and the process more. Then I was fortunate enough to take a Shaman workshop with Michael Harner, made my own drum, and went on inner journeys to both above and below, for both healing of others and for learning of self.

There's not a lot of people that I'm aware of who have learned both the elements of improvisation and shamanism, much less know them and do them masterfully, but my friend Keli Semelsberger is certainly one of those people. She and her work straddle the line between improvisation and shamanism, between learning, laughing, growing, and healing. She lives and works every day in the Venn diagram between improv and shaman.

It's been quite the journey she has been on and is still on and now with this book, she both shares her journey, and invites the reader to go on theirs. Like any good spirit guide, she is not here to demand you follow her path, as instead she invites the reader to discover theirs, and she shows the reader their possible journeys through improv, shamanism, and life.

One of my favorite sayings about art is that it takes that which is familiar and makes it unfamiliar and takes which is unfamiliar and makes it familiar. This is a good description of the process of art, creativity, healing, and play. In short, improv and shamanism. As you go on this wonderful book's journey of play, love, and spirit, I invite you to let Keli be your guide. You'll be in exceptionally good hands.

– Jonathan Pitts

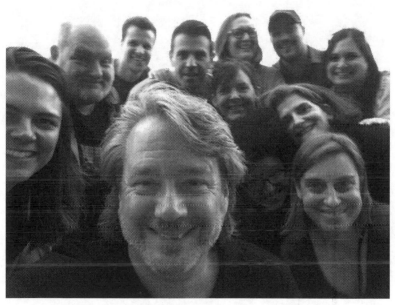

Jonathan Pitts (center) teaching a Charlotte Comedy Theater workshop

INTRODUCTION

Definitions of frequently used terms in the book:

* **Improvisation:**

Dictionary definition - to create something without preparation.

My definition - Improvisation is the skill to openly accept what is offered in the current moment, to embrace it without judgment, and create something new with whatever was offered. In particular regarding to comedic training and performance.

* **Shaman:**

Dictionary definition - Shamanism is a religious practice that involves a practitioner who is believed to interact with a spirit world through altered states of consciousness, such as trance. The goal of this is usually to direct these spirits or spiritual energies into the physical world, for healing or another purpose.

My Definition - A practitioner who works with spiritual energies to bring about dynamic change in the physical world for the betterment of their community.

* **Love:**

Dictionary definition - an intense feeling of deep affection.

My Definition - The divine essence each person carries within them that radiates in energetic form, representative of god source.

I WANT TO CLARIFY THAT the title of this book is not about me personally, though I do share my stories and perceptions herein. It's about the magic and healing properties of improv itself. I have been performing improv for over 26 years. It is my love and my passion. I have only been really learning my craft as an energy worker for the last decade or two. This book is a result of those studies and how I, and other improv instructors and performers, have been helping people find their authentic voice, have a place of belonging, and be a part of something bigger, while they increase their confidence and ability to communicate honestly. It's been happening for longer than I have been doing it. I am continually grateful for being able to witness its positive effects on the lives of everyone I see who get involved and stick with it.

For those of us that live an improvised life, and actually live the tenants of improv, we are incredibly frustrated that the world does not abide by our social contract. Our social contract honors all people's experiences. It encourages listening and building upon each other's ideas, and problem solving in the moment to co-create amazing results. Couldn't the world use more of that? Improvisers are energy workers even if they have no idea what that means. They are magicians and healers, wizards and alchemists, not to mention incredibly fun to hang out with.

My purpose for this book is to highlight the correlations and provide some other insights I have learned during my journey of improv and metaphysical studies, that as of now, I only get to share with the students in my classes at Charlotte Comedy Theater. I have been spiritually pushed to write this, letting go of any outcome, just like in improv. I don't know where it's going, I'm just going to commit to it and then let go. I trust that the people who purchase this will be the ones it is meant for, just as the people that show up for any given class or show, are ones that days particular messages are for.

I also wanted to point out to people that have no taste for the metaphysical or traditional religions, that there is another place to find yourself, your voice, your community, and get similar outcomes in personal growth, without having to struggle with philosophical or spiritual questions.

Some search and never find a true sense of self, but it's all close by, in the arts, in athletics, and other arenas. You just have to look. I speak to improv as it's my craft and how I have experienced incredible awakenings in my own journey.

I often tell people that improv saved my life (many times over) and also helped to forge it. I have had many students come to me privately, and say it had the same effect on them. These conversations are the ones where I become humbled and grateful that I have found my medicine, that I affected a better outcome for my life and others, just by being me, and doing what I love, even if it is just doing bits and acting like a lunatic for an hour and a half. You never know what will impact another person. But I have come to find that being yourself, and following your passion, is always inspired.

In the simplest form, improv increases the quality of one's life by teaching you to take risks, allow yourself to fall, make choices that feel good to you, work communally, be vulnerable, protect others vulnerability and create lifelong friendships. Who wouldn't benefit from any of these qualities?

As an improviser, I saw the value of being open and accepting things as they are, which allowed me to accept my spiritual calling. As a Shaman, I see why improv works the way it does. Improv manifests magic by holding a space for a tribe mentality. Improv requires being present, holding space for creation, not judging, engaging compassion, and to be in honest reaction. I view improv as the most valuable spiritual tool I have ever learned, and had I not done it for so many years, I would probably never have been in the mindset to accept the more difficult path of being a medicine woman, which takes dancing in the shadows of your own soul, in order to radiate light externally.

This book is my opportunity to expose people outside of my particular circle of influence to the two worlds I am fortunate enough to walk in. The material world, where I drive to class and teach my students, and the non-ordinary, where at the same time/place, but I get to witness

people's fear and self-loathing crackle and fall away. I watch their souls expand, and their being started to radiate with a far greater power than when they arrived all stressed out and caught up in the trappings of everyday life.

In improv classes and shows, we are not doing a traditional "ceremony" by calling in the ancestors, banging drums around a fire and singing ancient songs. But we are nonetheless creating a different type of ceremony by doing 8's, and warmups that bring us together as human beings with open minds and hearts, to let down our egos so that ancient power is invoked, and a transformation occurs. In the classroom, on the stage, we set up a sacred container, a space where the outside rules don't apply, and we get to dictate what is real, and what is not real. We drop the masks we wear in the outside world because we are accepted as we are, no matter where we are, when we come together.

Ordinary reality is not of consequence on the improvisational stage, the outside world fades away, as we create our new one, the one where we are all enough, we are all equal, and we get to share our lives and release our tensions as we learn and laugh together. Just as in a spiritual ceremony like a sweat lodge or a fire dance, we came together to let go of our perceived control, our fear, and to develop the childlike ability to just be, and to just be in community.

When my students walk into the theater, they do so as individuals. As different as can be, from different backgrounds and bringing in different energy based on what they are going through. Once we gather in a circle and shake off the outside world during warmups, we become one. As one, we can take the stage in front of a live audience, not knowing a single thing that is about to happen, but to trust that we will be creating together, as a tribe.

Whether it's a spiritual gathering or an improv class, we feel safe and accepted and able to create, as we were meant to. We no longer judge or fear our differences but are so grateful for them, as it brings more color to the palate that we are painting our improvised world with. It's such a

spectacular feeling, I wish everyone could experience it. I guess you can if you take an improv class from an inspired and experienced instructor.

We all have our own journeys. This is just what I have accumulated in regard to improv, on mine. It's about the amazing lessons I have learned, as much from improv as from my spiritual studies and practices. Improv is an amazing journey of connectedness and expansion. It is transformative, inspired, and definitely medicine for the heart and soul.

So, with that said, I'll begin the content of this book.

CHAPTER 1

Philosophies intertwined – The individual and the Tribe

IT IS NOT NEWS TO anyone that the world is in turmoil. We have forgotten that we are an interconnected part of the earth and the cosmos, stewards of all we see. We have become selfish, self-serving and self-destructive. If getting titles, material objects, and moving up the ladder made people satisfied with their lives, people would not be so angry and unsatisfied. We would be happy, right? Sadly, we are lost, scared, angry and confused as to why the American dream seems so far away, or once you get it, so unsatisfying.

We played by the rules and what did we get? Tons of bills, complicated relationships, stuff we don't need, kids who stare at their devices 24-7, and everything feels like it should be, well…better. We have settled for drama, depression, illness, and despondency. Our lives lose meaning, and this is a contributing factor to addictions and suicides. Not having a purpose or connection to others is absolutely toxic to us.

We symbolically pound on our chests as our isolation and feelings of "not enough" and brokenness deepen with every soul sacrifice, every time we deny what makes us thrive, because it does not make money, look good to the outside world, or is "silly". We were told our quality of life was based on having nice stuff and looking hot. Not on being centered, grateful, inspired, healthy and connected to others. We have worked all this time to get the superficial stuff, because we didn't realize that real happiness comes from much simpler and more easily attained pursuits. Things that every human has access to no matter what their social status is. Ourselves, and each other.

Our mission becomes clearer when we make a conscious shift in how we see the world and our place in it. A radical mindset shift, that we are not here to satisfy our ego driven goals, but to work in union for the greater good of all. Our choices become more in line with our heart, universal energies, and "flow" becomes a wave you ride, instead of swimming upstream or endlessly circle in an eddy of redundancy. In this way, you listen to what your inner voice tells you is good and valuable, not an exterior society that is clearly unbalanced and unraveling more so every day. So, we need to find our unique calling.

The cool thing about being you is that in all of history, there was no other you, living the life you are living, with your experiences, in this moment of time. There is no more perfect you following you around doing a better job with a better credit score and hotter partner. There is no certain way to do you, to be you, other than what feels right to YOU.

Fact: You were born uniquely you, proof - here you are!

Also a fact: You will die. Leaving behind all your stuff, your titles, and your energetic legacy of all you created while you were here. Your stuff may get passed on, your title or job someone else assumes, but the energetic tapestry of your actions reverberates long after you depart. What are the energetic paths you leave behind? Do people share stories of the crazy, fun adventures you shared? Do our kids have a sense of belonging to the world and a sense of honor to pass on to their kids? Or do the people in your life have a lingering, non-specific sense of fear and anxiety because it's what you lived, what you bestowed upon them, like an unspoken inheritance? Are you playing it safe, being "good" or in control? These are the questions that that lead to more questions like "Who do I want to be?", "What controls my decision-making process?", "What am I contributing to the world?", and "What do I do next?".

Here's how I look at it: I'm alive and I'm going to die one day, what I do between point A and point B is up to me. I might as well give all I have to help make this world a better place before I go, AND have a

good time doing it. If there will never be another you, EVER, shouldn't the world get the benefit of the authentic, fully emboldened you? Not you trying to play it safe, keep your head down, or try to be what you think others expect you to be. That's reading someone else's script for your life. Why not write your own?

We are the authors of our own life story, and sometimes we need to edit.

It is paramount to me that my friends, family, students, and everyone I encounter to know their value. And not because they are always good, or kind, or funny, or perfect, but because of the very fact that they exist. We came here to evolve, not to have our evolution stolen from well-meaning institutions or friends, but to realize what beauty, talent, and grace live within us. And to unlock the radiance of their individuality, not stuff it down like the last crab legs on an all you can eat buffet, only to choke on it and eventually puke in some unexpected way later. I think I just made a horribly specific analogy about having an emotional breakdown from suppressing emotions, with how buffets bring out the worst in me. I'm okay with it.

The best way for the people in my tribe (my friends, family, students, performers and broader, the world), to realize their value is because I treat myself and others as valuable. They experience honor because I treat myself and world with honor. I now allow people to see me hurt because I never want them to hide their pain from me. I find sharing their pain and mine an honor, it is a way of knowing what is for us and what is not for us, it is growth, it is recovery, it is a death of the old, making way for the rebirth of the new.

I had to learn to be vulnerable and authentic. I'm an ex-military police officer and an adult child of an alcoholic narcissist. If anyone has been conditioned to act tough and "never let them see you sweat", it was me. I had to let go of my own armor so I could see it in others, and help them feel safe enough in the world to let go of theirs. The thing about armor is that yes, it will protect you from the outside, but it does

nothing to protect you from the nasty stuff on the inside. And when you are covered in armor, no one can get in to help you.

As humans, we need one another and nothing taught us that more than the pandemic of 2020, now well into 2021. We have suffered the loss of intimacy, even being a stranger in the crowd felt good compared to isolation. But long before Covid -19, most of us were already in lock down behind the conditioning of society, and the fear of not being accepted for who we really are if we even ventured to try to find out.

As for my children and grandchildren, I now want them to see me cry, then dry my eyes, get up, do something about it, and become more creative than my circumstances…so they can too. I want my words and my voice to carry a massage of unity, hope, courage, laughter, and integrity. I want to look everyone I meet in the eyes and really see them and have them really see me, for better or worse. I want to be present, to be vulnerable, and to be real. If I am not, how will I ever find the people like me, my Tribe. That is exactly what I found in improv, "my people".

As I became an instructor and director, I ensured that the tribal elements of improv were the most important aspects of my teaching. In improv, as in life, if one of us fails, we all fail. If one of us is taking risks, the others will be encouraged to do the same. If one shifts the energy, the others shift with them. Instead of pushing their agenda, they let it go for the greater good. I wish these were universal values. I think the tenants of improv are great ways to live and to be in harmony with the world around us, and I will highlight some of those later.

There is not such thing as failure, only opportunities to be creative or a good story for our friends make fun of us forever.

I see all our lives as an interconnected web. No matter what we do, we cannot fail. Every path we take leads us somewhere. Businesses can fail, relationships can fail, programs can fail, but even then, we learned something. As human beings, we don't fail. We evolve or devolve. We

create or destroy, but we can't fail, because even in not achieving what we set out to do, we have achieved something. People feel failure if they expect to have a certain outcome or experience, but even though reality falls short of our expectations, the outcome is not flawed. It just is. In improv, we learn to let go of end outcomes. The only one we hold on to is to have fun and to support each other.

It's how we learn from the perceived failure each time that matters, realizing what does or doesn't work for us or the situation. A failure is a navigational tool, telling you to turn left or right, higher or lower. It is not an end, but a beginning of something new, something better, and something moving forward. It tells you what fits and what doesn't, for you. Not for anyone else, but for you.

It's like trying to find the right perfume or scent. I have smelled scents that smelled lovely on other people. Rushed out, bought it, put it on… only to discover it smells like cat litter on me. I have had relationships and jobs that also smelled like cat litter on me. What works with my unique chemistry, will be different from what works for others. It's knowing your chemistry, and your spiritual composition that helps you to find YOUR way.

We are all born with a genetic program. It colored our hair, eyes, skin. This programming gave you a taste for certain food, music, physical attractions, and all sorts of predetermined attributes. This code gave us each a natural curiosity, interest, or talent in specific areas. You may not find it until later in life, but it is there, waiting to be discovered. Our coding has given us a clue to our path, the path that would make us the most fulfilled, and therefore bringing greater joy to those around us. If you are naturally gifted as an artist, then to withhold the expression of that art goes against your coding. Eventually that need to create would want to surface, and though you may be feeling depressed or anxious, it could be a hidden part of you just expressing its need to be realized. Our inner yearnings tend to make us uncomfortable so that we get back on course. If we stayed comfortable, we would stay stuck.

In ages past, people would mark trails with stacked stones which indicated which way to go in the rugged terrain. Your natural gifts and interests are your directional stones. They direct you to what is for your greater good, what is your true talent, your passion and your medicine. Most of us never know these stones are even there, but when you learn to identify them, it's easier to find your way.

For instance, if you plant an apple seed; gave it soil, sun, and water… an apple tree would grow. You would not get an oak tree. The intelligence is already in the seed. It already has been programmed to be a certain height, have certain bark and leaves and produce a certain fruit. It cannot be anything else. Too many of us look around and see a world of oak trees and are told to be one. Try as we might, we are an apple, pear, fig, or willow, but not an Oak. We may even try to hide our apples, the fruit of our creation, in order to be more oak like. But that fruit, that is our gift to the world. That fruit feeds so many others in ways we can't even imagine.

When we do not accept and rejoice in the intended fruit of our authentic self, we are neither the oak tree we tried to be, or the apple tree that we are. We end up being a struggling, scraggly, and confused sapling, not knowing what to be. You see "saplings" every day. They are scared, angry, confused, and powerless people who have given up on reaching towards the sun. I see this in my corporate workshops so often. People are all working so hard at being professional that they lose their individuality, all the great things about themselves because they are trying so hard to be efficient, organized, or whatever their work culture expects from them. Once I start working with them, their inner spark starts to come out, and really surprise their coworkers of many years, who had no idea how spirited, funny or interesting they were. It's like we require people to whitewash who they are in order to consider them seriously.

Since my workshops feel safe, people really come out of their shells. It breaks my heart that they can't be that way 8 hours a day at work. We don't have to take ourselves too seriously to take what we do seriously.

Unfortunately, until the corporate culture starts rewarding individual expression while investing in team dynamics, work will continue to be WOOOOOORRRKKK.

Most people like their jobs and feel pride in what they do. It's all the other crap around it, like having to suppress who they are, or be fearful of losing their job if the make a mistake, that make people not like to go to work. If managers could remove those limiting obstacles, there would be a huge increase in skill retention, productivity, and profitability. I find it odd that corporations go through so many steps to hire an individual because they want their uniqueness, just to strip them of all their individually once they're on board.

Unlike my tree analogy, humans are also complex and can be many things. It's about finding the things that are inherent to you. You will know because they make you happy, at peace, and excited. The things that are right for you will make your heart sing. Follow that with all your being, for this is your authentic state. Suffering, being a victim, being controlled by others is not a natural state of being. Struggling happens, but suffering does not have to.

We are social/pack animals. You will not see a wolf acting like a bird or vice versa. As part of the animal kingdom, we were given intelligence and creative abilities in order to be faithful stewards and caretakers of the earth and all that's on it. Not to waste it or do it harm. Just as men, given more physical power in many cases than women, were not given strength in order to subject women to their control, but to protect them. Humans, as a pack, have gotten so self-driven that life seems to be more about who one can control others rather than who can lend support to others. If you watch any documentary on pack behavior, it is about caring for all the pack, not just the leader dominating for dominance sake.

We have left behind our ability to even perceive others as our own. We separate by race, gender, geography, religion, sexuality, politics and economic status. This is why we are so fractured as a species, and so off

track and unhappy overall. We don't even have the awareness of our connection, nor do we really feel that connection. If you hurt, I hurt. If you suffer, I suffer.

In many Native American traditions, it is considered dishonorable to have much when others have less. Giving is a noble practice. In other tribal customs, if one is suffering in the tribe, it is considered the entire tribes' problem and they all work together to find a solution. Instead of ostracizing the individual, they circle around and support them. Doesn't that sound amazing? Not to be cast off but to be embraced when you need it most.

If you think of the people responsible for mass shootings in America, it's been the people society has cast off. There is one of your root causes of violence, suicide & addiction, the isolation of not belonging. Same for how ISIS, gangs and other terrorist organizations recruit. They take the cast outs and make them feel valuable. People need to feel valued so much that they are even willing to hurt or kill other innocent people to attain it.

I always considered the improv community to be our own little, "Island of misfit toys". There are not a lot of places for sarcastic, a little bitter, highly intelligent and usually neurotic people to go to bond with one another. The exercises and games we play allow every person to shine, and create an inspired environment for us to bond. I teach students that it's okay to be themselves, to be seen and heard as the delightfully nutty people they are. Many people legitimately need permission to have fun.

The future can be changed by the values we teach and reward now.

I think the most important thing we teach our children is their value and that they belong to the world. Not the other way around, as in the world belongs to them. We should teach them to act honorably, and to contribute to the greater good. While schools are priming them for competition, separation, value based on measurable results, we are shocked that pretty much everyone we know has low self-esteem, and many have the trifecta adding, anxiety and depression.

That is when all the damage is done, early on, when we start measuring everything our children do against others and making it clear that we have expectations of them other than to be kind, be responsible for what you do and say, but other than that, have fun. Instead, we are raising human beings that feel they are never enough, and that is a hard self-value to break once it takes root.

My son is one of those unlucky kids who lost his senior year to COVID. He is expecting to go to college in the fall, but him going to college is not my primary concern. It is if he likes himself. If he does, he will be kind to others. I care if he has a sense of loyalty and honor. I care that he understands he must work for what he wants, and that he is not entitled to anything but what he creates in this life. I want him to have compassion for all beings and to want to serve all things without controlling anything. Isn't that what we all want for our kids and the people who surround us?

The person I just described will not be one that hits his wife, or abandons his kids, or spills toxins in streams, or takes what is not his. He won't sit on his hands when his neighbors need help. He will not whine and expect the world to cater to him. He will not tolerate racism, sexism, or any other form of discrimination, and most certainly won't be the person participating in it. I want him to love himself with all his human contradictions so that he can love the flawed world as well. I think its criminal to take someone's dignity from them and their ability to see the beauty in themselves, so they can mirror it to the world.

When people can not love themselves, they can not love the world around them.

We have given up so much in the name of progress. If we look at where progress has gotten us: we are nervous, angry, confused, over worked, overwhelmed, and downright unhappy. Some of the poorest people in the world are the happiest, those who have just the basics; food, water, shelter, and community. That's all we really need. But our society has gotten so complex that it makes it almost impossible to have the

basics without sacrificing our dreams. We must buy our food, buy our water, pay endlessly for our shelter, and hide who we are to be part of a community. How do we get those things without sacrificing our natural gifts and authentic path in order to survive?

That's where we need to get creative. The community that we need today is one where people have similar natural interests. I have friends that can spend hours talking about computer programming while I slide off my chair in boredom. When I go on talking about plant medicine, I'm sure they feel the same way. But we both have communities, like minded buddies that will delight in our mutual interest ramblings. The thing is if we don't pursue the things that naturally interest us, we don't find our tribe, others with the same heart song and vibration as us. This is our energetic community, the ones that we learn from and with. Our authentic community keeps us inspired and challenged. They create inspired action and divinely influenced work of all sorts.

To find your tribe you have to ask yourself, "In a perfect world… if money, time, responsibility to others was not an issue, what would make you happy to do? What do YOU want?" The first time someone asked me that I seriously could not answer because I could not unravel my wants from the needs of my family or the running of my theater. I had never stopped long enough to ask what I want. Luckily, I did because it led me to studying and teaching in Hawaii for a glorious 7 months. Now I ask myself daily, "What do I want?". Because it changes. Sometimes I need sunshine or swimming or a day in bed with a good book. Sometimes I need a long giggling conversation with an old friend. But it is okay to ask yourself what you need and then go about getting it. It's okay to happy and fulfilled. In fact, it's crucial.

What do you want?

I strongly believe that if we were to honor ourselves, and our neighbors, all beings, that we could change the world. It could take a few generations, but it can be done. But we can only do it by changing ourselves. Allowing ourselves to be, to just be, without having to

defend our choices, without having to keep moving back our personal boundaries and without having to hide who we really are. Instead of trying to control events, circumstances, and others, I can control my thoughts, actions, and deeds. That alone is a constant and arduous undertaking. I can choose to see everyone as an individual expression of Divinity, struggling like I do to find their way. I can see all others as powerful and magical beings, trapped by the social burdens placed upon them by themselves and others. I see each person as an expression of the same source in which we all come from and go back to. In this I can find harmony for me, and those around me.

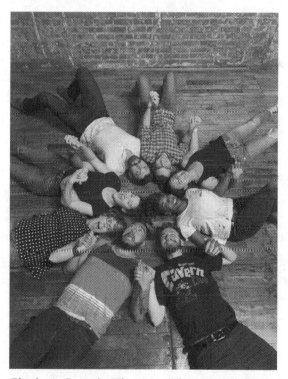

Charlotte Comedy Theater – The Last Blockbuster
Yellow checkered shirt at the top and clockwise: Mike Kekedy,
Taylor Abelman, Jayde Nelson, Dylan Fitzgerald, Phi
Hoang, Drea Leonetti, Bailey Griswold, Wilson Vaughn

CHAPTER 2

How I got here from there... and back again

MY FIRST REAL TRIBE, AND first time I really felt I belonged anywhere, was when I started doing improv in Chicago at Improv Olympic with the team Know Direction. I looked for community in the army, in family, in college, in church, in bars, and in the corporate world. I looked everywhere not even knowing what I was lacking. The need in me was so great that I was eventually willing to abandon the "successful" life I had created in North Carolina, to go to look for it. To satisfy this deep longing that would not let me stay comfortable, because I was not on my path. I was a corporate instructor for CIGNA, I was married to an Engineer, we had bought a house in the suburbs, and I was beyond miserable. I had been on the wrong path, and my heart would not let me rest until I changed course, dramatically. This is when I first learned that my inner voice was not crazy, I was for not listening sooner.

When all the doors and windows close, there is no place to look but in, and up.

So many people come to this place that feels like failure but in Shamanistic terms it's considered death of the old self, so that the new self can be born. It feels like your world is falling apart when it's actually being re-created. I've been there many times, but at least now I know what it is, and know that good things are coming behind the turmoil of change.

This was not so much the case when I was younger and the first time my heart betrayed me. I see it all the time in people now. They get in a state of desperation thinking something is wrong with them when

13

it's just time to let go and move on. Its okay you don't fit in or want what other people want. It's okay that people don't get you. Some of the most creative, intelligent, amusing and creative forces in human history have felt this way. When they got over trying to be like others and embraced their authenticity, they found their purpose here. People don't have to approve or give you permission to do what you need to do here. That's in your contract with the Divine, not with others. You are not here to please them but to create from your soul's individual expression.

In the early 90's, my life in NC seemed like I had it all. I don't know how many stories of transformation start that way or, "I had it all" or "I lost everything" but most of the ones I've heard do.

Having it all and having nothing feels the same when you are at a crossroads.

Nothing worked, nothing fit, and it all seemed like a grand lie and everyone around me is in on it, like the big Santa lie. Everyone said go to school, get an education, get married, have kids, buy a house, all that jazz and for me, it sucked. I felt lied to. I worked so hard to get all of these things, so hard, and once I got them, they meant nothing, (except my daughter of course, she was and is my world.)

I had gone from being a single mother in public housing, rolling pennies for my power bill, and on WIC, to a corporate executive who had a new home, nice hubby, a beautiful child, and my first new car ever. But I could have burned it all to the ground I was so miserable. I worked so hard to get where I was and once I did, I could not find any trace of joy or satisfaction. It all seemed so fake. I went to counseling because I could not understand my despair at getting what I thought I wanted. I worked out, I read, I wrote, but nothing worked. I felt like a fraud in my own life. Like I was playing a part in a show I wrote, but was not interested in. I knew I had created the life I was living, but it was absolutely wrong for who I was then, and who I was meant to become.

Eventually I prayed to give me some clarity, and some hope when I received what I thought was a random musing, "Go to Chicago." It started as a thought which grew to a gut feeling and maxed out at a heart's cry. It grew and grew in me like an anthem, gaining strength, until it was all I could hear. "Go to Chicago!"

I would have to leave my career, my marriage, my family, and my safe little home to follow this unreasonable and open-ended calling.

'Don't cling to a mistake just because you spent a lot of time making it.' - Aubrey de Grey

Against the arguments of everyone I loved, all my family and friend's wishes, I drove a 28 ft van to Chicago, in the middle of the night... with my 5-year-old daughter... in a snowstorm. Anyone who has been there knows that this combo is a rookie move at best. But I did it and felt amazing, as well as terrifying.

I could write a whole book just on my experiences in Chicago. How I struggled on $20 a week to feed myself and my daughter. (We ate a lot of potatoes and bologna). Or all the amazing teachers and performers that taught me this craft. I could not even begin to thank everyone who helped me in so many ways; it would just be pages and pages of listing. So instead, I will honor them by passing on the philosophies they instilled in me and add my personal reflections on their values as a healing modality.

After years in Chicago studying and performing at IO, Annoyance, Comedy Zone and other great ensembles, and with other great players, I got the message to go back south, just as painfully as I got the one to head to Chicago. I had done too much drinking, had too much ego, and was starting to not be able to recognize myself. I had to face my loss, and I had to slow down. I could see the toll on my daughter more than anything. She thrived as part of my improv life and was so loved at the theaters. She was even in a show with the Upright Citizens Brigade.

15

But I was a mess, the Chicago schools were a nightmare, and she was changing for the worse as well.

So, I packed up and went back home to Fort Mill, South Carolina. I had not lived there since my father died. I will tell you that going home is not the same when the person you went home to seek comfort from has passed, and the home you knew is now occupied by another family. In coming home, I had to let the reality of my loss sink in, and become the matriarch of my own family, since I could no longer run to Papa when things got tough.

I took whatever office job I could find and the best paying one was as an office manager at a steel company where the financial officer would call and berate me for things I had no control of, on the daily. I latterly cried every few days, and every Sunday night, I would be sick to my stomach knowing I had to go in the next day. But it paid better than most jobs and was near my daughters' school. I was terrified to have her alone too long after school, so I stayed.

It was during this time, I started teaching improv at the Perch Theater in Charlotte and did our first show July 17, 2001 for an audience of about 12 people.

I started CCT (then extreme improv) because I needed an improv fix and people to play with. I still needed a Tribe, and since there was not one in Charlotte yet, I decided to build one. I had not thought far ahead of what we would become, or that at this point I would have 12 teams with the only all-female ensemble and LGBTQ ensemble around. We have been recognized as Best of the Best many times over and recognized as one of the top 50 comedy theaters in the Nation! All because I was falling apart and knew that I needed improv as a lifeline, as medicine..

I started improv in Charlotte for very selfish reasons, and it has served so very many people since then. So never discount what doing something selfish in the name of self-care can do. I could never have known then how many lives this theater would change, how many students would come and go, and certainly not that we would celebrate our 20-year

anniversary in the middle of a worldwide pandemic. It's amazing what "failure" and neediness can accomplish.

The process you go through to learn improv well, is a kind of "be in the moment" boot camp. You can't be good at improv and not be present. You can't excel at it and be ego driven. You can't do this work and stay stuck, not grow, not form deep connections with other players. This work affects every aspect of your life.

Charlotte was vastly different from Chicago in every way as far as running a comedy theater. Charlotte is not an actor's city, so I learned early on that many students were mostly coming to me looking for something else, something deeper than a resume boost or a way to get that dream gig. In Chicago people were very career focused and did improv mostly to improve their acting skills and to be showcased for agents. But in Charlotte, I found people did not take improv so much to become a comedian, or to be a performer, but to learn how to play again. They want to recapture that authentic part of themselves that got tucked away under responsibility and reality. They want to know that there is more to life than work, eat, sleep, work again. They want to live full and passionate lives and want permission and a place to do that. So, I became the conduit for that. A safe place to explore the wildness that was just under the mask of who they were sculpted by society to become.

Had I gone to an actor's town like LA. I would not have learned the lessons I have in Charlotte. I would not have been able to teach the way I do now. I teach with way more philosophy, patience, heart, and with way more intuition than I ever would have if I had stayed in Chicago. The effect of that is that my players advance so quickly it blows my mind still. They don't compete with one another and even as our community grows outside of my theater to other theaters, we work with each other and are supportive. The environment is so different in some healthy ways, and I'm incredibly proud of that. As proud as I am of my incredible training and years of debauchery in Chicago. They are simply different, and should be, it's a different time in history.

It took years to learn how to be what my students in Charlotte needed for their journey. They guided me how to teach them instead of me imposing the way I learned in Chicago. Afterall, the majority of them wanted different outcomes than your traditional Chicago improviser, and I was teaching in a vacuum, there was no other improv here in 2001. I thought I'd never have that kind of community again when I left Chicago, and though it's different here, 20 years after I started it, the community is thriving.

Day one, I tell my students I don't want to know what they do for a living because it's not who they are, and who they are is who I will get to know over the course of the 6 weeks course. I tell them that they can be anything here. I tell them that they are safe, valuable, and on one hell of a journey. While they learn about themselves, what's holding them back, what filters they are using to beat themselves up, what are they doing on stage that they are also doing in life…in all that, they also learn how to be damned good improvisers.

I let them know that improv profoundly changed the course of my life and if they keep up with it, it will change theirs. I learned how to hug, how to take loving criticism, how to risk, and how to accept failures as opportunities. I learned what it felt like to be passionate, to belong, and to be valued no matter how much I sucked or was weird or different. I learned how to be comfortable in the act of becoming! As I continue to evolve, I pass on all I learned from Chicago, from my students here, and from Spirit. I let it all fly.

Allow yourself to be comfortable in the act of becoming.

I give all I have to each new group of students. It's a great honor to watch them crack open like a seed in the earth and unleash the beauty of who they are that had laid dormant onto the world. I've watched so many go from scared students to these confident, collaborative, fearless performers and lifelong friends.

It's pure alchemy, a transmutation from one form into another. Energy healers and Shaman transmute energy and move it as needed. We unclog energetic blockages and help people kickstart the person or place's connection to Divinity, to their own strength. In Reiki, I use my hands and stones. In Shamanism, I use drums, journeying, distance healings and visions. In improv, I use warm-ups and exercises and games. Different tools, same medicine. It's all about the transmutation of stuck, built up energy and moving it so a higher and more positive vibrational energy can move through. And there is not greater place to do that than in play. In Shamanism we dance and sing. In improv we play, (and we dance sometimes too, I love to have my class do group dance offs!)

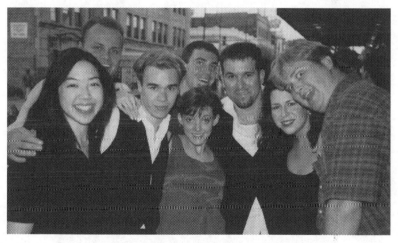

Know Direction — Chicago mid 90's
From left to right: Kate Lee, Jim Sharp, Stuart Ranson,
Keli Semelsberger, Bob Kulhan, Tim Chidester,
(sitting in) Jillian Jester & the late Stephen Wright

CHAPTER 3

Improviser and Empath

LIKE ANYTHING YOU LEARN, THE longer you do it, the more you see, the broader the picture becomes. I was performing, teaching, and directing improv before I really gave focus to my own spiritual path. I had always been spiritual in different ways, but I had not made that a priority. It was a program running in the background for most of my life. Leaving my old self behind, allowing myself to be in the act of becoming, was not comfortable. Just like driving that huge van to Chicago, on tiny roads filled with cars and snow, it was terrifying. Only instead of having my wide eyed 5-year-old next to me on my journey, it was like driving scared with my abandoned, abused, angry, and horrified little self that wanted to stay in control of everything.

I did change in Chicago. Chicago does not give you any other option, which is why I still go home when I feel stuck. My mother city always gives me clarity. I became a much stronger and a more confident person, surrounded by some of the most talented and authentic people. I also became very self-involved and self-destructive because I was avoiding the fact that right before my first class, my father died. I was running from my grief, the void left behind by losing my anchor in the world.

I was so relentless in my pursuit of improv, that everything else was ignored. I was so starved for the attention from the audience and affection from fellow players and love interests, that I gave little back, to myself, my daughter, even the friends who gave so much to me.

I learned what I needed to in Chicago at a time when some of the most incredible teachers were still teaching and the people I played with went on to become many of today's comedic stars, writers, and theater owners like me. When I came back South, I had different learning to do. Shortly after 9/11, I got into a relationship with a very funny man, who

also happened to have a penchant for pills. One that completely changed his personality from a fun artsy soul to a cruel and brutal control freak. I got him out of my house after 18 months of abject fear, but not before he fathered my son, Jaxon. He managed to stalk, harass, and threaten me for an additional 8 years, before passing in a drug related accident.

I put myself through an emotional grinder for a few additional years until I had enough of it. I think it finally gets to that point where you are aware enough to know that you bring all the BS into your life, even in the form of other people. It's not just them, it's you, it's me, it's what we allow and attract to us because we think that's what we deserve. Once you see that, you can't unsee it, and you either give up or you do something about it. Since I wanted to be a healthy and whole person for my kids, I decided to do something about it.

You will get in life what you tolerate.

When I accepted that I was the one who was creating a lot of the drama, then healing could take place, and my gifts and true nature could come to surface. And when it did, I changed more than I could have ever imagined. Years later, I can't even identify my old self more than a character in a book I once read. The self-destructive chick who you want to root for, but she keeps doing the same insane things that push people away time and time again. You eventually can't even read the book anymore because you emotionally broke up with the character. Well, that was me with me. Over my own crap, and after YEARS of healing work and self-discovery, I am where I am now. I will always have work to do, but I'm really liking the story of my life I am creating now. It's quite exciting.

Being a Shaman, energy healer, Reiki Master is not something that I chose to do. I never thought "Wow, I would love to see and hear things no one else can, or take on other people's horrible emotions, that would be so amazing!" It's just something I already was, had been, and spent most of my life running from... because it was scary as hell when I didn't know how to utilize my sensitivities and abilities. Even as a child,

I had out of body experiences and saw spirits or knew things I had no way of knowing. When in elementary school we lived on a highway in Michigan. Animals were always getting hit by cars and I would just know when one was out there, and I would lovingly scoop them up, and would hold them and sing them songs no one ever taught me in languages I never heard, until they crossed over.

As an adult, amidst all of the normal traumas of raising two kids alone, being emotionally abused at work, and running a tiny theater, these "abilities" seem to pick up pace. There are times I have tapped out, lost time, knew things I couldn't possibly know, had visions that were dead on, saw people or heard voices and even music that was not there. When the energy of that magnitude starts to build in you, it feels like going insane. I tried to drink it away, joke it away, and just thought the stress of my hectic life was getting to me. But the more frequently things occurred, and the more accurate my intuition and message got, the more I knew I had to figure out what was going on with me. If it were Divine in nature, I had to learn how to work with it. If it was not, I thought maybe I should get medicated to shut it down. I really had no one to go to and ask about these things. There were not spiritual communities in the deep south at that time besides Christian Churches, and they most likely would not have been accepting of my gifts.

Often natural healers have had to endure severe trauma early in life in the form of abuse, neglect, and trauma as a kind of compassion conditioning. This "training" early on, increases a healer's ability to "see" and relate to others who are suffering. There is an unseen element to people who have suffered greatly, and due to that "brokenness", others who are suffering have an inherent trust in them.

I can't count the number of times a stranger has told me things and then looked shocked and said, "I have never told that to anyone, I don't know why I told you!" Well, I do. Healers operate on a certain frequency, that attracts people in need like moths to a flame. Sadly, if you don't know that you are attracting these people because you have the power to help them and send them on their way, you might just end up collecting

them. Feel free to consult some my of my ex-boyfriends for proof of this pleasant phenomena.

I wish I knew I was empathic early on. When you inadvertently take on others emotions, you are constantly being manipulated. It is hard to sort your own emotions from those of people around you. I didn't know it until many years into my spiritual training that this is one of the reasons I drank so much when I was in Chicago. I was trying to buffer all the emotional input that was coming at me from all over. I was self-medicating. I know now how to protect myself, especially in big cities, but I still get exhausted being around too many people for too long. Unless I'm in an improv class or show, you won't find me around large groups of people, even pre pandemic. It takes too much to keep everyone's crazy stuff out of my energy field.

Besides being an empath, I had other disturbing gifts that made life more interesting than it needed it to be. I could always sense spirits, ghosts, and ancestors around me. In any given room I see big dark shadows moving around, or fluffy white ones, and even things that look like broken disco balls that will shimmer in the air or drop down in flashes of light. It can be very disorienting at times. I see images on land of what used to be there, of what happened there, like mini movies. I often know things that are going to happen and even if I don't know exactly when or how. I often go into a mini trance state at stores staring at something I don't need but when that happens, regardless of whether I purchased the item or not, within 24 hours there would be a need for that item.

I couldn't even meditate without going on what I now know is a shamanic journey. I would be trying to get my Zen on, and suddenly be transported through time and space and see colors I could not see with my eyes. I'd see beings and places that left me sobbing because of the love and beauty they shared with me. The energy would pull away and suddenly, I would come back with some profound knowledge all blissed out. But then I would look around at my life, my belongings, my home and it all seemed so foreign and think, "what is all this stuff

around me, it's so weird, so purposeless, what am I doing here?" and have a really hard time functioning.

It is also depressing to be transported psychically against your will and experience such radiant love, and then be unceremoniously dropped back into one's regular own life. It's that feeling you get when you come home from an amazing vacation, and know you have to go back to work, and you really didn't want to come back at all, only 1000 times worse. Unless you vacation in heaven, then it's the same.

I studied every book I could get concerning energy medicine, which lead me to Reiki, which is hands on energy movement. I became a Reiki master and though it really helped me to understand and work with energy in and around the human body, was only the beginning of the training I would receive from masters around the world, and all paths led me to shamanism.

The definition of Shaman has been described as someone who can access the spiritual worlds in order to help their community in the material world. The way I described how I see the world is that if you take a picture of a landscape in front of you, that's the material world we all live in. Say you see a lake, a boat, trees, clouds and sky. Then add one of those overhead projector films. On that film that overlaps the "normal scene" there are images that are earth bound clouds of different shapes and colors, I might "see" a vision of kids playing on the shore, thought they are not there now, they may have been there earlier, so they left energetic footprints I can see and know they are not really there, but its still there for me. I can hear the trees sing to one another, and get emotional pushes from the clouds and know if things are going to be mellow, or if danger is around. I may even pick up the feelings of the people on the boat and know the health of the water and fish in it. Things like that. It's just like layers of extra information. That is what it's like in nature, imaging the layers in a city with lots of people around or in a crowd. It's exhausting AF.

The two are not separate. I see and experience a sunset on the beach the same, but then the sun, clouds, sand, or silent people around me

are also projecting messages, feelings, ideas, and images and I'm like a receiver that gets all the stations. Learning how to discern what was mine, spiritual, or material has been a long and frustrating process.

Eventually I realized that not accepting this part of me was harmful, not the messages that turned out to be valid. I also didn't think I was worthy of spiritual gifts. I have struggled with low self-esteem all my life, like everyone else I know. I often dismissed messages or visions because I was certain that I cannot be important enough to be given sacred messages, or to tell someone their departed grandmother wants them to rest more. I didn't feel worthy. But as I have learned, we all are worthy, and we all have these messages, we just must listen.

The most radical event that made me certain that something psycho spiritual was going on with me was when my dear friend had heart failure, a stroke and was in a coma for several days and was not expected to live. I had just enough money in the bank to fly to Chicago from Charlotte, and I noticed I was weirdly calm on the plane considering I didn't know if I would even make it on time. I didn't pray for him to be saved like I normally would, instead what came out was, "Let me be there for him. If he needs to stay, let me help. If he needs to go home, let me help." And that was it. I had no worry or fear as I flew. I walked in the hospital, he was alone which was really strange given his large family and huge friend base (since then I have had this happen multiple times, that when I am drawn to a place where I will be called upon to do ceremony, or cross over a spirit, no matter how crowded it is when I get there, people will be completely gone when it comes time for spirit to work whatever magic through me.), I saw my friend who was larger than life, so tiny in the bed, and I was afraid to touch him with all the hoses and tubes and monitors.

As I sat there, I heard as clear as anything. "Touch him!" I recoiled, like I could catch the coma, or step on a hose and accidently kill him. I didn't want to. Then again, "Put your hands on his face & talk to him!" So, I did. As I talked to him, I made fun of his new tattoo. I teased him like I normally would have, and then I put one hand on each side of his face

which is not a normal gesture for me, and that's when it happened. He opened his eyes and looked at me like, "Hey, Keli.", then a confused look like, "What are you doing here? You don't live here anymore." Then, "Where the hell am I and what's going on?!" All of this was so clear as if I heard his every thought. I was still standing there with my hands on his face and my jaw dropped, tears streaming down my face when the staff rushed in freaking out because he woke up.

All I know is what I felt. I felt a power of absolute love go thru me in that moment. Not just my love for my friend, or his for me, but the absolute pure love of the Universe, of Divinity. The rest is a blur. His mother later swore I saved him, and I reminded her that I was just the vehicle, that the saving was an agreement between him, and source. On a side note, I had his mother come visit me in spirit and give me a message that helped me protect my own son on the night she died. I think she felt she owed me, and the things I wrote down that night, came true within the next 4 months, long after I forgot about her visitation. My friend is still alive and amazing today.

Though I have been a part of many miracles since then, I'm clear in knowing and explaining that I am not doing the magic, God/Great Spirit/Universe, whatever you call the intelligent, loving energy that flows through all of creation, that is where the magic comes from, I'm just a good receptor apparently.

All practitioners of healing arts are conduits. We are, in Shamanic terms, a hollow bone. We allow the restorative energies of the Universe move through us and into people, places, and things. The reason I got the call I did, and had just enough money for the air fare, the reason I was so calm and the reason that I was told to act, was for my friend. Because he still has work to do here. It was not my will. I had surrendered it. I was the tool to make my friend's will manifest. I am just honored to have borne witness to that miracle.

That's what this life thing is all about, being of service to the greater good. Not just me and mine, but all beings. Not all acts will be as miraculous

as what happened with my friend. But that event, being witness to, and a vehicle for a miracle, changed my world view. I have experienced so many little ones since then, that I know life is filled with them. Every day is a miracle. Every smile, hug, laugh, and helpful thought or deed is a miracle to me. They don't have to save lives to change lives.

There are so many people awakening to this in themselves right now. I wanted to share an overview of my experience and how it relates to the work of improv, which just happens to be the main channel in which I use my gifts. Becoming a healing arts practitioner is a calling. A tough one because you have to look deep inside and heal yourself continually, layer by layer, ugly thought after ugly thought, it's not for the complacent. It is something within you that won't let you rest. It's an over developed sense of compassion and inability to remain neutral when others are hurting, even if it's on the other side of the world. You feel it as deeply as your own pain. This type of sensitivity would never be the choice of any rational person trying to get along in this world. It is terrifying. It makes you appear crazy and feel crazy at times, until you come to terms with it and develop ways in which to utilize these gifts and see them as such.

I do recommend everyone learn to protect their own energetic levels because we are all affected by other people's energy. This is where I started my journey in becoming a spiritual practitioner, by learning how to protect myself. From there, I worked for years on just healing my own wounded soul. As this part of my practice grew, so did my ability to sense and help others. All modalities and ceremony I do with clients, I have personally used for healing within myself. I'm a different person who now lives in a world of magic and gratitude instead of self-loathing and fear. So, 20 years later, I know how to manage my gifts, and how to focus on the beauty of all that is around me, instead of the ugliness.

Believing in magic allows you to start creating it.

Don't be a Star Wars fan and then doubt it when you see "the force" working in the world or doubt it's inside of you. "The force" is another

term for Universal Energy, Divine Spirit, God, Great Spirit, and Love. It is stronger than anything because it is connected to everything, as it created everything.

Don't take my word for it. Try it yourself. How to connect would be another book, and there are many out there on spirituality by people with greater wisdom than I. I prayed long and hard for the right teacher and studied with visiting Shaman and tribal leaders until I found Robbie Otter Woman who was also in NC. I studied with her and found an amazing and all-inclusive spiritual community and even traveled with her and other Shaman to South Africa.

The best part was that I could talk to people who saw things in a similar way and could give me guidance. People that understood and gave meaning to the wacky shit that continued to happen to me. They could also feel shifts in energy, and each have their own gifts. Its where I finally met my spirit tribe, who guided me further on my journey and continue to teach me so much.

I had my improv tribe that had always been my life blood. But as I evolved and changed, I needed people to learn from in another community. I needed to know the ancient ways. And boy, I have learned from some incredibly gifted, wise, and authentic people. I have participated in fire dances, gave offerings to Pele at the mouth of an active volcano, climbed Mount Shasta in vision state and been fortunate enough to participate in many other sacred ceremonies from various cultures. I have found balance. I do not keep the two parts of me separate anymore. The fire dance Keli is also the improviser Keli. I dress, act, and speak the same. My improv classes are full of spiritual insights, and I act like a fool at sacred ceremonies too. I've integrated. The best thing is they both value the healing powers of laughter. I will never be done learning. In improv or in the metaphysical arts, as both are intuitive and ever expanding.

But for now, these are the places where I see them merging.

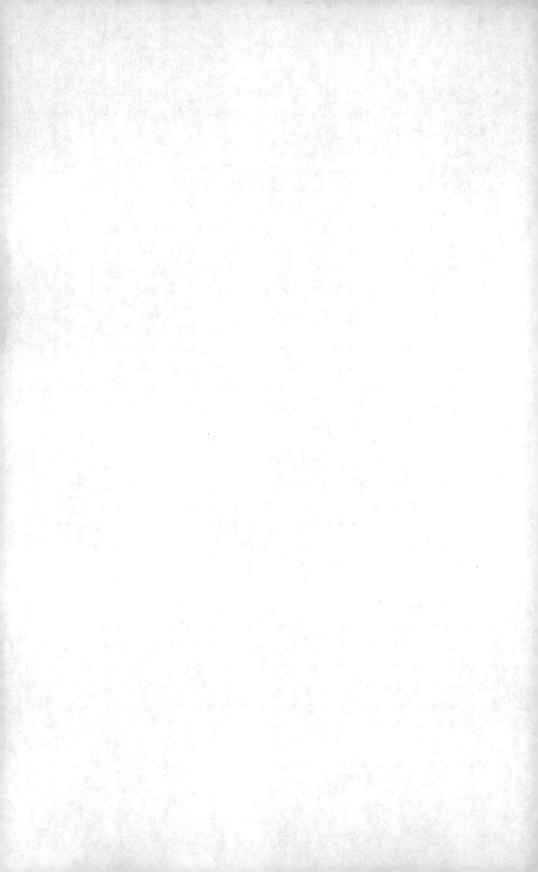

CHAPTER 4

Improv Medicine and making others look good

I CALL IMPROV MY MEDICINE. Healers have different medicine. I have friends who are gifted Mediums, Shaman, Reiki masters, people who heal with crystals and sound and you name it. I work with plant medicine, Reiki, and Shamanism. I use them all together. So, when I refer to improv as my medicine, it's the way to deliver healing energy. There has been a lot of research on the healing powers of laughter. In adding to that, I believe the people who get the most out of the healing powers of improv are the improvisers themselves. We get to strip ourselves down, let go of ego, live in the moment, be a part of community, surrender, create, inspire, and laugh.

I'm going to go through some of the main tenants of improvisation, and then expand on the spiritual application of these tenants from my point of view. I know that one of the reasons our shows are so delightful to watch is because the players are having so much fun! They are building on each other's ideas without judgment and they are creating a magical world right before the audience's eyes.

That's what we can do in everyday life; it's just taking the practice out of the theater and into the world. That is what it's all about. Bringing the philosophies out, like a secret ancient practice, and realizing that they are. I want to put the two together here and bring out some of the most beautiful things that I have learned, so hopefully my trials and tribulations can be to everyone's benefit.

As I grew as a "healer", I remember sitting in prayer and asking how I can serve. I am but one person, how can I help the homeless, the lost, the sick, the dying? How can I help bring peace to a world riddled

with bigotry and war? I got several answers. If you have never really let Spirit talk to you, you'd be amazed at how your answers come. Some guides are gentle, some are funny, some are direct, but they all know your heart, your mission, and all that is yet to be. They say that praying is asking a question, and meditation is listening for an answer. I believe that to be true.

My message was "You are already doing it." and it was accompanied by visions of all my students, watching them grow and learn, bond and thrive. If we affect but one life here in a positive way, we are doing good. I was in tears as I watched this spirit montage of the amazing relationships that were created because of my love for improv. That moment, that vision, is the reason for this book. I want people who teach and perform improv to know how powerful what they are doing is. To honor it. I want people who are lost, to know there is a fun way to find their voice, and their tribe.

The great news is that if you don't like to go to church, or meditate, do yoga on a hillside, or all of the other "spirity" things people do these days… you can go to an improv class, cuss and act a fool, and get similar results in your personal growth.

The things you get from a spiritual practice like meditation is that you learn to be present. You learn to work with your emotions, not stop them or judge them. You learn to be in the moment, and not have your mind be where your body is not. You learn to relax into the moment of where you are and let things flow. These are all the same skills you get from improv, only in it's in a group and everyone is awkward and as weirded out as you are at first. Then you wonder what took you so long to start doing this!

Our world is so preoccupied with competition that our economic survival depends on it. As improvisers we win or lose as a team. It's not about who gets the laugh, or who had the stronger character because a strong character does not exist on its own. It needs someone to coexist with. We need each other. If someone does something we don't expect,

instead of acting as if they have just ruined our day, we are joyous that a new toy has been thrown into the playground. Each time something unexpected happens, we focus on it, not in disdain because something happened out of our control, but as an opportunity to create something new & amazing.

Now, can you imagine if you did something that was unexpected or that appeared to be a mistake at work, and everyone got excited? It doesn't seem realistic that they should. After all, unlike an improv show, there is a bottom line; there are customers and bosses to please. But the truth is that in the real-world, things do go wrong.

Accidents happen and people mess up. Those are facts that you cannot get past no matter how efficient or micro-managed a business is. If we looked at a mistake as an opportunity to get creative, not only could we fix it, but we could also prevent it from happening again. People are so criticized for messing up that they hide errors, or lie, or both... only create more damage down the road. We can't learn from mistakes until we admit that we made one. If we get ridiculed, demoted, put down, or fired for making a mistake, no one ever learns. The mistakes keep happening and valuable talent squashed because of fear of failure. This is why in improv we say there is not failure, only opportunities to be more creative, just as it should be in business, at home, in school, in relationships, in child rearing, and in all artistic endeavors.

When I get on stage with an ensemble, I know my number one job is to make them look good. I will take any bizarre thing they say or do, and I will make it seem absolutely like the best thing that could have ever happened. If someone comes on stage and calls me the Pope, then by God, that's who I will be. If they start singing, I join in with them. In our improv world, everything anyone does is what we all do; it becomes all our reality. Making each other look good means I have a group of people looking after me while I look after them. I can say and do whatever comes to me and they will back me up. It's the greatest feeling ever. It's a safety net.

In our world you are never out there alone. Whatever you offer, others will honor. Can you imagine being in a business meeting (and I've done this with business clients to great success) and throwing out an idea or solution that sounds crazy, and have everyone there actually consider it? To have everyone honor that idea as if it's the greatest thing ever and toss it around until its true value becomes clear.

The initial idea may not be brilliant, but if you keep expanding on the idea, something amazing always occurs. We find the "crazy idea" was just a key to unlock the door to all the other viable options. But you have to say YES to forward motion of thought, of creativity, and of joyous creation to get there. Even in our personal lives, do we put our partners or kids down when they say or do something off putting? Yes. What if we realized that wherever they are right now, is where they should be and whatever they have to say is as valid as anything we have to say? What if we honored people in day-to-day interactions the same way improvisers honor each other on stage?

Some of my greatest relationships in life are with other improvisers, and it took way too long to realize it's because of the social contract we have as improvisers. So why not treat others the same way, whether they know the "rules" or not!

"You can only meet someone at the level to which they have met themselves" - author unknown

Imagine if in every group we work in, our birth family, the family we have created, our friend group, our work group, if all of them behaved the same way. The world would be bursting with creative, inspired, and authentic people. Not that improvisers are always happy go lucky, but we are when we are improvising. Because of the magic of the art, that is telling in itself. I genuinely believe that improvisers suffer greatly outside of their improv world because the outside world does not function the same way.

I do very few, non-improv or spiritual activities because the rest of the world doesn't get it and there is so much drama and turmoil because

of it. I have the same reaction after leaving a 3-day fire dance. I just experienced a group of people coming in from different walks of life, from all over the place and working in complete harmony, holding each other sacred and being openly loving and supportive while still getting a great amount of difficult physical and spiritual work done. It's utopian. Yet we all return to the "real world" which does not share the same dream. They do not dance the same dance. And it's hard to adjust. I can't speak for all spiritual communities or all improv troupes, but in mine I feel completely supported and whether we agree or not, each person will care for me in whatever way I might need, as I would for them.

I've got your back

This is what my cast has always says right before we go on stage. This is what they told me when I asked them to do a show at the children's hospital and the homeless organization and many other outreach programs. It was instant. "I've got your back", and they always do. Could I expect that kind of support in other areas of my life? Not always, and definitely not in the corporate world I used to work in. But I believe improv can change the corporate world, which is why I work with so many companies providing improv-based team building. I've been doing corporate training for over 25 years. Bringing improv in was a no brainer since it's way more fun. It allows participants to really experience the feeling of being supported, not controlling everything, and being in the moment, instead of me just talking about it, like I am now. I'd rather be doing a huge workshop than writing a book, that's for sure.

Since one of the main tenants of improv is to take care of your team, scene partner, your fellow players, it's in our nature to jump in as needed, whenever needed, for whatever is needed. More than a few times I ended up on my hands and knees on a hard wood stage being a chair for another player to do their scene. That's it, not talking, just being the chair. Sometimes, in life, we just need to be the chair. Sometimes having someone's back means just giving them a safe place to rest and do their thing.

Having someone's back is not conditional. It's not, if I like what you do, I will be there for you. No. It's understanding that in life, just like a scene, we are not fully formed when we do things. We do not know what the outcome will be, and we are trying something right now in the moment. Having someone's back is being there for them no matter how it goes. It means doing what you can do to help them, as they need it, as they create the scene of their life from moment to moment. It's still their scene, but you are there to hold space for it, to witness their journey, or to join and add something positive to it if needed. Imagine in life someone having a hard time, it's their scene, they may need to talk, cry, leave town, whatever. Having their back means helping with their scene. Not taking it over, judging, editing, or controlling it...just what's best for them at that moment. Being there.

In making others look good, then entire group looks good. If you have 8 people all using their energy to make everyone else look good, that's 8x8, you do the math. It's not having all 8 people trying to make themselves look good, competing, shutting each other down, pointing fingers, and trying to outdo each other. We have all seen power struggles. It's not pretty and no one looks good. No one is better for it and it's not fun to watch or participate in. If you have everyone working for the greater good then everyone feels valuable, works at their highest level, creates trust which creates closeness and loyalty. That kind of functioning benefits everyone within whatever group you apply it.

We can bring a bunch of people together and call them a team. If they do not have each other's back, they will not trust each other, and Lord of the Flies shit will happen all over the place. If they don't trust each other, they will not be authentic or risk being "wrong". If they do not risk, they will not create on a higher level.

In tribes, it is understood from birth that the survival of the individual is linked to the survival of the tribe, and the food source of the tribe. We are so individually focused that we have lost that mentality. If something happens to someone in my family, we are all affected. If my country

goes to war, or elects a megalomaniac to the white house, we are all affected. If there is nuclear war, we are all affected. We are a tribe, there are different circles of the tribe that go out in rings getting bigger and bigger, but we are all one.

In ceremony at the Fire Dance, that came as a vision to one of my teachers, Robbie Otter Woman, this application of taking care of others is mind blowing. The dancers' dance in the arbor, processing emotions in a trance state. Everyone in and outside of the arbor are holding the space for them to dance. As they dance and heal, they dance for the world, not just for themselves. In the dance, a dancer will often be processing very heavy emotions and cry out. The rest of the crew cries out too. We whoop and holler and support even the cries of pain with a sound of support. It sounds completely foreign to my American experience, but I can tell you when I danced, and I lost my shit, hearing others howling with me made me feel so loved, so not alone, so understood and so carried by their voices as well as their love. It's a unique experience but one that taught me so much.

As The late Bonofuto Some' taught me in a grief workshop, we are not meant to grieve alone. In her tribe, if one person separates themselves because they are upset or ill in any way, other members of the tribe go to them because they know that if there is something wrong with the one, there is something wrong with the tribe. Unlike in our communities where we judge, isolate, and chastise people who are suffering. We go hide and cry in our rooms, alone. Our grief is meant to be witnessed and not carried alone. This causes great distress in our psyches and in our communities. People with drug addictions, mental health, homelessness, are perceived as flawed and cast out. This goes against our natural pack mentality. Those separated from the pack are doomed to fail as they need others to support and love them to whatever degree of health is natural for them.

On the outer ring of the dance, there are "dog soldiers." Dog Soldiers live outside of the tribe and make sure the tribe inside is safe, have food, and are taken care of. Because the honored Dog Soldiers stay

outside the center of the tribe, all are safe within. That to me is like the improv instructor, holding the safe space for all the improvisers to dance their dance of transformation. Inside the fire dance are the dancers, elders, drummers, wisdom keepers, moon mothers, fire fathers, dance coordinators, chiefs, and fire keepers. Everyone relies on each other. The entire 3-day ceremony is an "I've got your back" fest of love and encouragement. Everyone is happy to do whatever needs to be done to serve the dance and the healing it promotes in the world.

Improvisers are dancing a dance too. As people start to learn, they let go of old things, and learn new. They are processing old emotions, letting them go, and developing new constructs to replace old ones. In the fire dance, the first day and a half is letting go of old stuff, then there is a transformational phase, and then a day of dancing in celebration of the new things each person will manifest in place of the old yucky stuff they discarded. That is often how I see improv working in people's lives. They start out processing a lot of fear, anger, grief, silliness, competitiveness. Then after some time, they start bringing more multidimensional elements to their work. It's a transformation for sure, I've seen it over and over again!

CHAPTER 5

Taking care of yourself

TAKING CARE OF YOURSELF IS more than just the basic thing of get there on time, drink water, exercise, rest and all that critical self care. In improv, it means come on stage and grab an emotion or point of view immediately. I advise players to make eye contact with another player and grab the first emotion they feel based on that, or to see how they feel by the way they walk on. The main thing is not to walk up to another player with nothing, expecting them to create everything. This means make a choice for yourself. Feel your feels and choose your filter based on what is actually occurring for you. I may choose the old man that hates everything but the squirrels that live in his attic, because I may be feeling how much I like animals more than people (which is often the case). I may choose to be innocent and upbeat,because I'm playing with someone new, and I use that as my filter since it's already present within me. No matter what anyone does on stage with me I know where I come from based on my filter. That's how I take care of myself on stage.

I don't rely on the other people to create for me. From there we co-create our relationships, characters and the pattern of the scene together. It starts off with each person having feelings, then having feelings about the other person, then evolving everything from that space. I can come on wide eyed and innocent and find out that I'm a surgeon. I'm going to keep my filter and add the new information of surgeon, now I'm wide eyed and doing surgery. "Hearts are so amazing, it's like they were created from unicorn dreams!" as blood spurts all over.

Be an active participant in the creation of your reality.

Taking care of yourself in the spiritual aspect means the same. I don't hand the responsibility of my creation of self to anyone else. I am not

my past actions or beliefs. People in our lives do help us form our character. Through interactions with others, we learn about ourselves and we can take on things we like and hopefully avoid things we don't like, but we are ultimately responsible for ourselves. We are never just one way, locked in stone forever and ever amen. We are constantly in the act of becoming, and part of improv is that we get comfortable with discovering who we are as the scene goes on, as more information is shared. We have a hard time with that in life. We tend to think that "this is who I am, what I do" and we get stuck. We are never finished becoming. Like a painting, until that last brushstroke is on, it is not done, more colors and depth are placed every moment on the canvas of your life. Until that last stroke is done, you have no idea what the process of being you is supposed to look like. And when that last stroke is done, you die, so you aren't going to care anyway. You don't stop evolving because you turned 21 or 30 or 50 or 70.

Taking care of yourself is having your own voice.

Not giving a shit what anyone else says about what you are doing and how you are doing it is healthy. It is required to have sovereignty over your own being and your own journey. As long as it does not hurt others, then why not? (do your own risk/benefit analysis here, I don't need lawsuit). Taking care of yourself means not doing things that hurt YOU. Eat what is good for YOU, not a waif on the front of a magazine. Dress how YOU feel good, not anyone else. Surround yourself with people who get you and make you feel supported, valued, and loved. If you don't have that, make creating it priority one. Go do something, take a class, or get in a group that is interested in whatever floats your boat, and let people be there for YOU. If you don't let anyone in, if you are not vulnerable, no one will know you and then they can't be there for you. If you are in a relationship, or business that drains you, hurts you, abuses you, GTFO! I have been there. I know how hard it is. I left with nothing, and you can too. Get help, get out and trust the Universe to take care of you.

Misery is your soul telling you that where you are is not for you, and it will push your misery level until you have the courage or desperation to act. Take care of you! You are the first part of us and we. You need you and so do we. Others may think they need you, but you for sure do. Kids, lovers, friends, and bosses will only benefit from you being who you were meant to be. The people who genuinely love you, want and need you at your highest self. For most of us, that takes change, courage, surrender, and a sense of humor. Taking care of you means to follow your passion and your dreams. You have no idea how long you are going to be here. Why would you be given a passion if not to live it, to fulfill it? If you want to be a singer, but American Idol told you NO, find another way. Just sing.

Don't ask anyone for permission to be you.

One reason I didn't go to LA when I left Chicago is that I didn't want to have to ask people permission to do what I loved. I wanted to do improv, live on stage. I didn't want to do commercials or movies; I just wanted to keep playing. So, I started my own theater. One little hole in the wall after another. I did it for me. I am blessed at all the amazing things my theater has done, all the great friendships, creative projects, movies, radio programs, and so much more created from what I started, but that's not why I started it. I didn't expect it to ever pay a bill. I started it because I love improv. I love doing it and even more, I love teaching it. It does and always will make my heart sing. It gives me faith in humanity. It shows that we can take random people that are so completely different and after a few short weeks, have them working together seamlessly, with trust and genuine affection. It works. It unites and heals. Had I not been willing to challenge who I used to be, and move into the potentiality of who I could be, I never would have taken my first improv class, or taught my first student years later.

If you believe in the placebo effect, you believe that what someone believes becomes their reality.

Now you may have no taste for my beliefs in ancient teachings, and I could defend my beliefs and my experiences all day long, but to what end? The way I see it, if I am crazy and I assigned meaning to things

that were just coincidence, and therefore changed my world view, then does it matter? If I believe that we are all capable of healing ourselves and the planet, that what we think and pray on can and will manifest, and that fairies will return missing objects if you ask nicely... who is hurt by that? Certainly not me.

If I'm delusional, then I'm a happy delusional person that is so crazy, I manifested a life as an artist. I do outreach work that changes lives, I am not afraid to make choices, speak my truth, or create close bonds with my friends and family. I also speak to plants and animals, dance and sing in my house and yard, and celebrate the littlest of things with ridiculous excitement. I'm a happy and productive "crazy person".

So please don't look me up on social to message me that I'm nuts, I am clear on that most likely being the case, and spent my adult life cementing the foundations of being joyfully outcast from "normal" society. That message will be met with a "Thank you!"

I happen to think that people who stick to with imperial evidence are crazy, and they are missing so much magic! If you are not happy and see that the world around you is a dumpster fire of inequity, it's easy to lose hope. Hope is essential for life to have meaning for us humans. So as long as anyone's way of living, gives them, or those around them hope, then they are on the right track for them, who is anyone else to judge if they are happy. I'm happy, so "don't F up my Godshow." "Godshow" is my term for how I see everything as interconnected with meaning and grace, which gives me hope and keeps me inspired.

I see Divinity at work in everything, so it's all a "Godshow" to me. I'm just a player while I'm here. If I stay inspired, I can continue to inspire others. Which is the greatest gift of career in improv, inspiring others. So, I enjoy the big Godshow I'm fortunate enough to be an ensemble member of. I do my life scenes and watch it all unfold carefully, so I know when to take focus and when to give it away so that I can listen, and support others as they create.

What's similarly cool is that so much of what our ancestors believed, how they managed to keep flourishing, and many of the spiritual practices that I ascribe to, are now being backed up by the scientific community due to new technology. There are machines like Kirilian cameras can now detect auras and holes in peoples' energy fields. They have taken photos that show a person's fractured auric energy field before a Shaman does work on them and after, when the field is complete, whole and smooth (indicating optimal emotional, physical, and spiritual health). Doubters are only denying themselves the possibility of childlike happiness and discovery that would make the world a more exciting and magical place to live. People are welcomed to stick to their pessimistic guns if they like. You do you; I'll do me.

Do what you need for you. If you are a Baptist minister that always wanted to learn ballet, do it. Dear God, please do it. Doing something for yourself only makes you more interesting and brings the possibility of authentic relationships to your door. I know at times I wanted to be more interesting just for me; I had to be with me all day long. Learn new things; expand your mind, your community, and your heart.

In spiritual terms, we chose to come here before we got into this body. We had some lessons we came here to learn or some experience we wanted to have in this form. So here we are. Unfortunately, part of this journey is that you must remember what you came here to do, and for some of us, maybe it was just to visit, who knows. But in taking care of the self, healing of the self, we also heal the world.

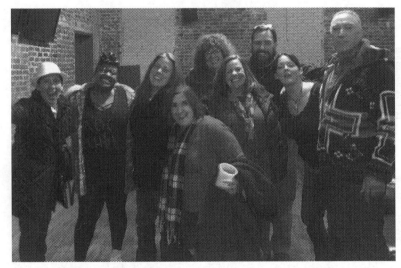

Some of the fire dance community members at a Charlotte Comedy Theater show. Left To right: Sara Eshe Zuri, Miya Crudup Zuri, Brandy Winn, Karla Smith, Robbie Otterwoman Hill, Beth Arrigo Webb, Trai Hill, Keli Semelsberger, David Webb.

CHAPTER 6

Say Yes, and...

SAYING YES IS THE MOST powerful and empowering word you can say to someone. The principal of "Yes, and..." is that you accept what your partner offers you as if it is real and honor it by adding to it. If someone on stage says to me, "Uh mom, you parked the car in the front yard!" I would immediately accept that gift of information to be true and then and it by adding information by saying something like, "Yes, and I'm all out of vodka, go check under the diaper changer." I agreed that this was true and added information of how much worse a mother I am than originally inferred. We will do this back and forth in a conversational manner until heightened to a type of climax or edit.

Saying "yes" is forward momentum. In life you say yes, you do things, go places and carry on. "No" stops all creative energy flow. For instance, if I wanted to go back to college, (I don't, please don't call me University of Phoenix) I could think, "I don't have the money, or the time for all my classes and so on because I'm coming from a place of I can't or No. Now same thing if I said, I want to go back to school with a Yes mentality. My thoughts that followed would go on a totally different "yes" path. "I could get a Pell Grant, schedule classes on nights I don't teach class, and I could find a way." Yes, always finds a way! And suddenly I'm researching educational funding and moving forward on this desire to go back to school. If people didn't say YES, you and I wouldn't be here. Thanks moms. Yes means, "I'm in!". It does not mean that I'm not scared, unsure or unable to renegotiate later if things change. What it means is that I'm game. It leads to discovery, possibility, creative thinking. No stops all creativity and movement. No stands still.

Yes always finds a way!

For better or worse, I've said yes to things without having any true comprehension of what I was saying yes to, but I trusted my gut. Even the fire dance I mentioned earlier. I said Yes before really knowing what it meant to be a dancer in it. I heard fire, dancing, and all my favorite spiritual people were going to be there. I heard all the different things you could do and if you were called be a dancer, then dance. Well hell yeah, I'm always called to dance! After I said Yes, I found out that it was also three days of fasting, no water, no food, and no talking, while dancing. What?! After having anxiety about being without food and water, and even an inside bed for 3 days, my heart still said yes.

Yes is not reserved for the obvious, like if I want more chocolate. It's even more powerful in your life when it's regarding the unknown. Yes is letting go of outcome and going along for the ride with 100% commitment. Not only did I say yes, but I also showed up, I did the fire dance, and it changed my life. It kicked my spiritual journey into high gear, and I have gone to every dance in the states since. They are huge a part of my life ceremony now. Say yes, something will happen. Say no and I can tell you not much will. Yes is trusting yourself to handle whatever comes. Yes is knowing that something special is right around the corner. YES is life affirming AND is giving something back.

YES is creation.

Yes and. It's saying, "I will honor your gift, and I will give you one as well." It's honoring the gesture of being included and valued in the game on stage and the game of life. If you want an interesting life, say yes, show up, and do your best. I think "Yes and" is not just an improv tenant, but a great way to live life in general. We hear "no" so much that it's usually one of the first words a baby masters. NO, NO, NO! Even as adults, it's we can't do this or that, we have

to get home, we need to eat better, no carbs, no gluten, no callbacks, no raise, no social life, no sex…or whatever. No is everywhere. Yes is fun and powerful and hopeful. Embrace the yes, and…see where it goes.

Joes Raw Bar Cast at Stage Door Theater
From left to right: Andy Smith, Dave Wilson,
PJ Kelly, Drea Leonetti, Keli Semelsberger, Jack
Davis, Austen DiPalma, Jason Spooner

CHAPTER 7

Being in the moment

BEING IN THE MOMENT – this also tackles letting go of judgment. There are 4 things that keep you from being in the moment: judging yourself, judging others, being in the past, and being in the future. If you are judging yourself, thinking you are not good enough, then you are not at all in the moment. If you are focused on taking care of others, on being of service to the greater good, that self judgement falls away. The ego dissolves. Like anything you do where you are actively involved, you are not thinking of you. You are doing. You get out of that critical head space and engage fully in what you are doing. If you were helping a little old lady who fell, you would not be thinking how fat your ass is while doing it.

We are all at our best when we are in service to others.

Part of why improv works so well is where our focus is. Our focus is on others, on listening to what is going on, to saying yes. You cannot judge yourself while doing this, nor can you judge yourself and be fully emotionally, physically, and intellectually present. If you are judging yourself at work, you are not bringing your A game. We hold back when in judgment of self. And if you go back to the concept of there is no failure, only lessons, then you can start to pull that judgment off you.

You don't master anything you do on the first try. Anything you are good at you got there by sucking a lot at first, a little less later, and you kept doing that thing until you got good at it. Most things we master we love so much it was worth all the nicks and scrapes in order to get there. Don't judge the nicks and scrapes; they are battle wounds of a battle well won. Even relationships and jobs that didn't work out were more fine tuning and greater mastery in the art of being you.

No one has ever been you before. There is no one being you, running parallel to you, with a better credit score and hotter body, showing you that they are doing you better than you are. The only person that is judging you really, is you. Your friends and family don't really care what you are doing; they care HOW you are doing. If not, they are not really on board with you.

Worrying about what others think of you is a losing battle. When people meet you or me, all they are doing is sizing themselves up against us. Are we bigger, stronger, smarter, cuter? People are so self-consumed that no matter what judgment they make, it's about them. They want to know how they rate in comparison to whatever abstract judgment they make about you. It has no merit on your actual value or the value of the interaction or what becomes of the interaction. That's just what people do. This was a great realization for me.

I realized that no matter what I do, say, how I look/dress, that people would make their own assumption of who I was, so they could somehow mirror how they rate. I am free to dress, look, act & be in the world in a way that works for me, which changes, because we change. People will still assess me in comparison to them, but I'm being authentic. I'd rather someone like or dislike me based on who I really am. Then we can really be friends if they like me, if not, someone not good for me got screened out instantly. Yeah!

There is that little asshole voice in all of us that tells us we are not good enough. I've taken that voice to the mat several times, and still do. The thing is, it's filtering too. It got filters put in a long time ago, when we made assumptions or were told certain unpleasant things about ourselves. For me it was that I was not part of the family, I did not belong, I was not valued, and was worthy of abuse. The only time I was at all valued, or at least not verbally abused much, was when I was completing tasks. So, I became a task master. I did it for everyone. I did so much that I became very controlling about my

doing. If others were not doing too, they were wrong. I was not good unless I was doing.

It was exhausting AND I became resentful of those I did things for. Even if they didn't ask me, I would jump in, handle everything, and expect some undying loyalty for my efforts. In effect, what I did was steal other people's experience of handling their own shit. I infantilized a lot of my family by being so controlling and having a savior complex. Then I got to be a martyr and a victim because, in my book, nobody did for me like I did for them. A bad cycle. My filter of only being valuable when doing created a pattern that repeated itself in all aspects of my life. I couldn't change the pattern of behavior until I changed the filter. I had to go back and figure out, when did I decide that I was not worthy without doing?

It's amazing the meaning we will extrapolate from events. Even as adults we make up things about events and hold others accountable for the meaning that we placed on things. Let's look at a child's view. Mom and dad get divorced, and they even tell the kid that it's not the kids' fault, Mommy and Daddy just aren't happy together anymore. That does not keep the child from thinking, "If I had been better, argued less, caused less problems, this would not have happened". No matter what anyone says, the child still makes up a story and believes that he/she is responsible. We do that as adults all the time. We will attach meaning to something. I could wear something I'm not sure I look good in and exchange a glance with someone making a horrible face and think, "oh, they think I look horrible in this too! What was I thinking?" Then all night I am almost apologizing in my way of being because I think I look so awful. However, the person who was making a face at me may have just been holding in gas, who knows. It's not about what they think of me, but I made it about me. I created a meaning out of thin air due to my filter that I don't look good. See how it works. It's insipid.

Let's go back to my, "not valuable" filter. The way I changed that was in a meditation where I went back to when I first remembered making this assumption. I had a nice conversation in my journey with my little girl

self. A journey, in this context, consists of going into a trance state and visiting other realms of consciousness. In this journey, I explained to my past child self how my situation at home would change, all the things that I would accomplish, and that I didn't have to work so hard to please everyone. I explained my value was based on the love I give and not the tasks I complete. That it was my heart that matters to those who love me, not my talent, or my tenacity, but my heart. I did this a few times, going back farther and farther. I will tell you now, that it took a huge burden off my shoulders. One I had put there. I had interpreted the circumstances of my life, made a negative judgment of myself and then it became a program always running in the background of my psyche, filtering life events in a negative way, which affected everything I did.

Not being good enough or not valuable, is an odd concept to me. Even though I have battled it most of my adult life, and I don't know anyone who doesn't. If the creator took the time to create you or me, then we are worthy. We are here. How could there be a worthy or not? Compared to whom or what? We don't have to earn being here. If we do, it happened before we were born, and we clearly already passed the test, right? I believe that all beings are worthy by the mere fact that they exist. If you believe in a creative force in the Universe, know that it believed in you enough to create you. Intellectualizing this is easy. Living it is a practice all its own.

In judging yourself, you are assuming that everyone is thinking about you too. Honestly, no one cares that much. Not that they don't care about you, they do, but everyone is too busy judging themselves to really be concerned about what you are doing. No one cares about my hair, my crazy hippy outfits, or that I'm still upset about Prince dying because I was sure we would still hook up in this lifetime. They care if I'm happy, and despite Prince, I am happy. No one cares how smart I am, or if I'm the best improviser in the world or the worst. Their journey goes on despite mine. No one is keeping score. Only ourselves.

In one of my particularly vivid and frustrating visions, I was asking for insight to my life purpose. The response I got was, "The main thing

for you to do in this life is to realize, (yes, what, realize what?!) there is nothing that you have to do." Wait... WHAT?! I don't know how to do that. I can do things. But to just realize that I don't have to do anything... My OCD screamed out! But it was clear. I don't **have** to do anything besides eat, drink, sleep, learn, and love. What I choose to do with my energy is up to me. I will not be loved or unloved based on what I do or don't do. Unrelated, the same vision I was also told that everything is a rental here, don't get too attached. Which I thought was funny. But it's true. This body, my home, it's all temporary. I'm pretty attached to my body because I need it. It was like Spirt was saying in a conspirator whisper, "drive it like you rented it!" about life in general.

So, let yourself off the hook. Who cares if you watched 4 hours of Nurse Jackie last night, or ate old marshmallows, or colored your hair, or don't floss, or have a flat butt, or a big nose, or under $10 in your account? NO ONE CARES about that stuff. You know what they DO CARE about? How they feel around you. Do they feel at ease, do they laugh, do you make them feel valued, do you really listen when they speak, do you care about them? That's it. When you think about the people you like, you will know it's true. You like to be around people that make you feel good to be around them. If you like to be around people that put you down, you may want to check your filter. Clean that out and get some new friends.

People care about how you make them feel.

Others are so busy judging themselves, leave that to them. We need some judgment to determine if we want to be around certain people, do they feel safe, are they negative, are they energy suckers, and the like. Your body will tell you that. If they walk up and you take a step back, listen to that. If you are leaning in and moving closer, listen to that. What they wear or look like is no measurement of who someone is or can be to you. Only 20% of our first impression of people is based on what they say, the other 80% we are energetically sniffing their butts on levels we can't even imagine. We pick up things that we have no words for, just feelings, and those will never betray you.

Judging others has more to do with wanting to be right or the need to compete. If you are judging someone as below you in some way, you are making yourself right or better. Then you are making them wrong. To be right, someone must be wrong. For instance, I have never understood the trend of wearing pants below the butt, then wearing a belt. It seems like a contradiction and really inconvenient for walking. However, is it right or wrong of anyone to wear their pants like that? Neither. I'm judging, not creating.

If I see a soccer mom with a minivan full of kids and a bunch of stickers on the back of her entire family in cartoon form doing sports poses, I immediately think, "I bet she gulps down vodka by the case in her water bottle". Is it funny? Yes. But is it fair or true or kind? No. Is it judgment? Yes. She is on her journey, and she signed up for that. If she asked or needed, I'd help her. I could meet her, and she might be the sagest person I have ever met and be my next great teacher. I don't know. My judgment may block me from even approaching her. Ok, that's a lie. I'd talk to her or anyone (the weirder the better), but you know what I mean in theory. Our judgment of others is a way of creating distance and we don't need any more distance in our society. We need union and harmony.

In the 20 years that Charlotte Comedy Theater has been in operation, I have seen something magical happen. In every class. Day one, people are in class barely speaking, from such diverse lifestyles, all scared and fiddling with their phones, become outgoing cohorts midway through that class. By the end of a few weeks, they are hanging out, coming to shows together, become great friends, and often form creative partnerships outside of the theater as well as within. When people are in a place where letting go of judgment, taking care of each other, having responsibility for yourself, and saying yes is the norm… trust builds quickly, and magic happens. Close friendships form and creativity soars.

I wish every corporation would put their employees through improv training. I think it should be mandatory in middle school and high school, but that's me judging society as it is as dysfunctional. I'm aware

that I make judgments too, that doesn't stop me. I'm still a work in progress too. But when I do, I remember that no one is right or wrong. We all have our truths, and if I believe in fairies, I'm not wrong. If you believe God puts people in hell, you are not wrong. These are the realities we have constructed and live in. If the reality you are living in is not making you happy, then change it. It's that easy and takes some practice, but it is that simple. Change that filter, tell yourself a more interesting story and say yes, then you will move forward.

Living in the past is another way to stay out of the present moment. When there is no past or future, only now. This was so hard to wrap my head around at first, but I think of it this way; if I think about something in the past and it makes me feel sad, that feeling is here now. Not the event, but the emotion it carried which is real for me, it hurts. So, it's here now, not in the past. I have brought it front and center to where I am. It's no longer in a place gone by. Things that happen are only memorable because of the emotion they gave us that we relive if they are still unhealed. Just by thinking about them, we bring them present.

The same thing applies about future thinking. If you are thinking about something a week from now that you are nervous about, you are not nervous a week from now, you are nervous now. Your emotional context in any given moment is controlled by what you are thinking about now. If you are thinking fearfully about the future, you will be upset now, if you are thinking of a good or bad expense you had prior, you will experience that emotion now. It's not when the experience occurs that affects you, it's when you THINK about the experience. How many of us still blush thinking about an embarrassing experience from our youth? Even your body is responding to an experience that is not actually taking place right now. That's how powerful our thoughts are.

Just like the blush of an old embarrassment or the memory of a steamy moment with a lover, our bodies react, as if it were happening now. It is now. Dreaming has the same effect. You can dream of your lover cheating and wake up mad as hell at them, it was real for you and your body and emotions are still there. You must talk yourself down, so you

are not a jerk to your partner when they didn't do anything wrong in this world. Just thinking about things in a positive way, brings greater light energy to this world. You can feel it in yourself if you focus on thinking in the possible instead of the fearful thoughts of doom and dread. Your energy shifts and good things start to happen, synchronicity comes knocking at your door, sending you telegrams, and emailing you.

Our body reacts powerfully to our thoughts. If you can change your thoughts from negative to positive, you can create harmony and balance within your body and your energetic field. You can even attract or repel certain kinds of people based on the thoughts you are having. If you are sitting at a bar fuming about what a dick your boss is and someone leans in to talk to you, I will put money on that person is a dick like your boss. As the laws of attraction will tell you, you draw to you what you think about.

"What you think about you bring about." - Rhonda Byrne

If you are thinking about how amazing or beautiful something is, and being in gratitude, you will attract people who are more grateful and appreciative of beauty. Your thoughts control every aspect of what happens in your life, from what you can manifest, to how your body feels. Being in the moment, means to focus on where you are and what you are doing. It doesn't mean to clear your mind. It's about keeping your mind where your body is, in the present moment.

In improv, it's what is going on right now on stage or in class. It's really listening to what is being said, watching body language, feeling the pitch and tone of the scene, being ready to edit the scene and get the people out of that scene when needed. It is being so in the moment that you are inspired by what is happening when you react, not thinking about what should be done or said. It's about being able to be comfortable having nothing when you walk out, knowing that it will develop in its own sweet time. It's allowing yourself to react to whatever is given you, to really feel the impact of what is said and to respond honestly to it.

In "real life" we don't respond honestly to most things. We believe the deodorant commercial, "never let them see you sweat". How do people know if they have crossed a line and hurt us if we don't react to being hurt? How to people know they have touched our heart when they don't see those tears? How can we know how we are affecting others, and where we really stand, when everyone is hiding their emotions all the time? The only emotion that people seem to have no problem showing is anger. Anger is what I call a "not real" emotion, and all my psychologist friends will freak out about this. I'm an improviser not a shrink, so take my word for what it is, an opinion. By not real I mean that is a byproduct of other emotions that we are unaware of. Anger is a straight up "go to" for a lot of people.

However, if you really looked at the situation when you get angry, and think, "Why am I angry?", 99% of the time it is because some person, some situation, or your own filter made you feel as if you were not valuable. Most of the time, anger is like a lid on a jar full of emotions we don't want to deal with. Anger is usually a side effect of a different emotion. Anger is caused by feeling devaluated, humiliated, not important, or shamed. But these are too hard to look at and deal with, so we just get mad. But when we get mad, and react with anger, it makes the other person defensive. Then we just pass the anger back and forth and things get out of control. Here are some examples; someone cuts you off in traffic, no wreck happened, but you are pissed. It's because that guy thought his agenda was more important than your life and property. You were devaluated. Your mate talks about someone else being hot, you think that means hotter than you, or you are not hot in comparison. So, you feel devaluated, now angry. Your kid gets in trouble at school. You have done all you know to teach your kid how to behave and either you failed or gave him dumb genes. So, you feel unimportant or guilty for his/her behavior, or you are so mad that your kid would disrespect your rules and standards for behavior, disrespect = devaluated. Kids.

The cool thing about knowing this is once you get in the practice, you can change your life with this anger management tool. Next time

you get mad, figure out what lesser emotion is under there, the ones you don't want to look at… and look at it. Then if you can talk to the person from the real space it came from, show or tell them that's how you really feel, you will not get anger back, but compassion. For the example of a man saying some other woman was hot, and instead of wife getting mad, she realizes that she does not feel valued sexually as she would like to by her mate. If instead of getting mad or hating on the other woman she can say something like, "Hey, when you said that it really made me feel like you don't see me as that sexy, that hurt." In a healthy relationship the mate would reiterate how hot and beloved you are and make you feel better. If you tell someone honestly how they have hurt you, 90% of people will fall over themselves to fix it. We don't naturally want to hurt others. If they do not and go further into hurting you or blame you for being hurt, you are most likely not in a healthy relationship. I have been there, and it is never good.

As an energy worker I'm very aware of my thoughts and feelings. I know that thoughts of a lower vibration; negative judgment, harsh words, anger, hatred, violence, jealousy, guilt, shame…all can affect my body in negative ways. The energy of negative thoughts, create negative emotions, and negative emotions cause harmful reactions in my body like an increase in the production of cortisol, the "stress hormone". Increased levels of cortisol also contribute to weight gain. So negative thoughts can also make you fatter. That little factoid should make most of us nourish our thoughts just out of vanity alone.

Like attracts like. The first tenant of Huna is that the world will be exactly what you expect it to be. I'm saying, if it's not what you want it to be, then change what you are thinking about it and it will change your experience. It's hard when we have been wired to think a certain way for most of our lives, so it takes a completely different environment, practices and support to do so. That's why I believe improv classes create such dynamic changes in people so quickly. We do crazy exercises, participants are encouraged to risk and fail and laugh, are accepted no matter what and it creates an environment that is ripe for artistic expression and change.

My beliefs have been empowered by all I have personally experienced, my quests for understanding that have taken me near and far, and my true desire to move from being an angry, wounded person, to an inspired, and loving one. It just took practice, a lot of improv, and the tribe that allowed me to be flawed, broken and dirty, so that I could find my way home again. Home to who I really am, not who I was pretending to be. Without my improv experiences, I don't think I would have ever had the confidence to find myself, more or less the awareness to know that I, my authentic self, had been missing.

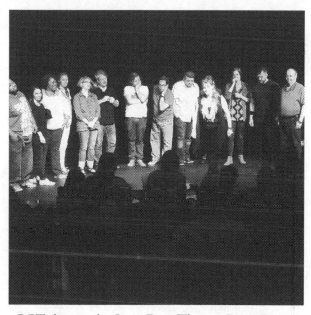

CCT show at the Stage Door Theater. Brian Briscoe, Lisa Samuel, Kimberly Mccrary, Cora Polsgrove, Drea Leonetti, Jonathan Pitts, Austin DiPalma, Steve Orrell, Eric Mccrikard, Jen Altzer, Derek Vorhees and Jim Carson, Keli hosting in front.

CHAPTER 8

Truth in Comedy

THE CORE CONCEPT HERE IS that who you really are, what you believe, what you stand for, and your real-life experiences are funnier than anything you can make up. Skilled improvisers can react honestly in the moment. We have real emotional reactions in made up situations. As I said earlier, we have learned to cover up our emotions and as an improv instructor it's my job to get students comfortable really observing their emotional reactions in a way they may have never done before. Not only do I encourage them to notice them as they come up, but to express them.

An improv classroom should be one of the safest places for people to explore their emotional baggage. Lay it out on the stage and we will all play with it like props. This is why trust and the way the instructor holds the space in an improv class is so important. It's never about being funny, it's about being real. Because humans, being real, are hysterical. We are broken and crazy and courageous and beautiful! In being what we are, we are relatable to our fellow students, and to our audiences. Same with real life. The more real we are, not pretending to be invulnerable, tough, always happy or a loner, we create space for others to see us as we really are and draw like souls into our experience.

Often our lives are like clogged arteries, with unexpressed emotions clogging up the works. The good thing is you don't have to cry on a couch or do primal screaming, though they are not off the table if that is what you are called to do.

If we examine what truth is, it's different for everyone. My truth about an argument may be the opposite of the person I argued with. It usually is or we would not be arguing, right? Truth in comedy is bringing your truth in any given moment, with all your knowledge, damage, passion,

history, impressions, and viewpoints with you, and honoring them as enough. They make you and who you are in this moment, the way they differ from mine, the way your point of view reflects different light on the same moment, that is precious!

That is where you and I can create together and see things differently by sharing authentic experiences and reactions. This space of sharing our truths and letting that be enough is where all human advances came from, in art, literature, science, medicine...comedy. This place of being who you are, right now, this moment in reaction to this event. That is where the improv instructor, therapist, energy worker, our family, is working to get us to. Right here, to who we are being right now.

I could react to the same experience in a myriad of ways depending on where I am in my life, if I have had enough sleep, if I just heard something sad, or just marched in a woman's rights march. My current state of being will filter the light I shine on an experience, just as yours will. It's honoring those places of being as neither right nor wrong, but what they are in the creation of this moment.

A seasoned actor or improviser will call upon personal experience to use in a scene. If in a scene I'm begging some troll not to leave me, I will tap into my ever-present abandonment issues and really be there. The reason people react to good acting is because we can feel the emotions that the actor/improviser is feeling. Just like you can feel it when you are near someone who is experiencing an emotion. We have all asked someone who we are feeling some funky emotion from, "Hey, what's up?" Only to be told they are fine. Either to deal with it on their own, or to build up more energy to dump it on you later. Either way, you know when someone is feeling a heavy emotion. That's why theater works. The actors move the audience emotionally. That's our job. But to do that we have to feel it as well. To really feel it, we have to be willing to surrender the possibility that we will never recover from feeling old hurts (it's not logical but it's a common fear) and lay it all out there.

If I ruled the world, acting would not be called acting, it's experiencing. If you are acting, you aren't really in the moment, you are acting like you are, and others can't feel your pain or joy. If you are experiencing, then you are sharing that with others. If you are acting like a good friend, but don't really feel it, that person will know. Same with all relationships. We have been taught to be so distant from our emotions that we are not sharing what we really feel with others.

If I can be on stage in front of total strangers and with no dialogue, and make them feel pity for me, or worried that I may explode in anger, then how can I not have my own family understand where I am coming from? Possibly because I am more guarded with my family than in my improv world because of social norms. I have a safe non-judgmental place to express myself in the improv world and if I flip out, people will think I'm just a good actor, not that I just lost my shit. At home or at work, I don't feel safe from judgment. No one is coming out to have my back and join me in a tantrum or cry fest. And that is what I hope changes. I want our entire society to have the same social contract as improv teams. We would be creating amazing things all over the place and "yes and" a peaceful, fun, and ridiculous society that is nothing like what is being created now out of fear, separation, and judgment.

Here are some reasons that it's important to really be in the moment with your emotions:

First, you are an artist. All people, performers or not, are artists. You are creating your story, your life experience. Artists create because it's who they are, they must. They also create because they are communicating who they are in this time and space with others. It's that need to communicate, to be heard, that drives us to do the wacky stuff we do. It's all about communication. We are sharing and we want to be heard, seen and understood by others.

Second, it's healing. There is nothing more powerful than sharing what you feel with another person. Having someone witness your pain or joy makes it real. The joy can grow, and the pain can heal. We usually cover

up what we feel because that's what society told us we should do. But it allows pain, guilt, shame and insecurities to fester and grow. Like that stuff in the back of the fridge that you don't want to open because you can't identify where it came from or what it has turned into. Emotions fester like that. Sharing them takes them out of that dark place.

I use improv to share my experience with the world, some people play sports or use different art forms, the main thing is that you express yourself and your journey here anyway that is healthy for you and those around you. No one wants to be the person to smell what's in the old container in the fridge! Once you do, with a professional, a friend, a stranger on a bus, through art or motion… you are free of it. It goes to the greater consciousness like throwing a rock in the ocean. You are no longer holding it.

Remember how 80 % of us feeling other people out is non-verbal? Well, that applies here too. Our audiences (improv or just people around us) are just like us. They are not dumb. They can see, hear, and feel authenticity. If you put yourself in what is happening, and are present, others feel it and are attracted to it. That's how we keep attention on stage, and how we keep relationships off stage.

We are hard wired for compassion. Not just feeling bad when others hurt but feeling good when others triumph. If you hear of a horrible accident a friend was in, your heart pounds and you are panicked, though you yourself are not at or in an accident. Your body reacts. You may even gasp and put your hand to your mouth or heart as you are hearing what happened. Just as if you hear of a touching story or watch a video of people rescuing a puppy from an ice-covered lake. Your muscles may tighten as they all struggle to pull the heavy ropes, you may feel cold for the puppy. But for sure when they succeed and the puppy is in the arms of the rescuer, you want to see the face of the hero and the dog, because we learn to see emotion in others eyes as an infant. You want to see the relief and the joy. You want to see it because you want to feel it. Even though you are not physically involved in the event, you are emotionally and it's as real for you as it is for them. Isn't

that magical?! If we watch positive content, we can feel the result of other people's positive actions. I've never felt bad when seeing a video of someone helping another person. I feel awesome, like I did it. That's our oneness. That's our universal compassion that binds us all.

Eye contact and facial expression was one of our first lessons in interpreting the world around us. That's why eye contact is so important in establishing trust with others. We want to see and feel what you are bringing to the game. If you avoid eye contact, it's harder for us to tap in to that 80% of sensory evaluation that we do without having a clue we are doing it. This is why we pay attention to body language. People lie, their hearts don't. There are often exterior manifestations of the heart despite what the person may be trying to accomplish.

The heart will betray you if you don't listen to it.

The heart has a direct line to our higher self. It does not think, it feels and sends messages to the brain and the stomach. It tells the brain, "I'm hurt, do something!" and the brain, based on past experience, will make a decision (In my case usually a misguided one) and put the body into action. The brain can be blamed for a lot of things that go wrong, often because it uses outside information to determine how to please the heart. If it listened to the heart purely, it would make better decisions. For instance, if I am dating someone and just love the shit out of them, my heart may say Yes, more, Yes! But my brain will apply social standards to the situation and fears from my past relationship and may be acting from a place of NO. And thus, the relationship fails. Then you can't seem to get over this person your brain said was a loser or whatever. Your heart still loves that person and holds on until someone of equal or better vibration comes along (and they do).

Or say I'm offered jobs in two cities and I really love the feel of one place, but that job has crappy benefits and less pay. So, I choose the better job in the town I didn't like as well. I may stagnate in that "better" job always feeling regret about not taking a chance on the cool location I truly desired, and it could have turned out that the reason

my heart liked the other city was not about the job at all, but a mate, or someone that would lead me to a better job, or a great hobby I didn't currently have.

The thing is your heart, being of such a high electromagnetic vibration, is in contact with divinity and receives messages on a different level. Our brain is consumed with filtering through so much content, but our heart is feeling from a higher plane, from a grander view. From the view of the Eagle, instead of the view of the insect. For the insect, the world is noisy, huge, scary, and overwhelming. From the vantage of the Eagle, things are put into perspective and one can see an overview of how all the pieces are coming together. It's quiet and contemplative in the air where the Eagle can ride the wind currents, see what it wants, and grab it with determination.

The insect is always afraid of being eaten, looking for places to hide in the tall grasses which obscure its view of the larger picture. We Americans tend to see things from the view of the insect, caught up in survival mode. Many indigenous people, sages, wisdom keepers, and teachers see things from the view of the Eagle. We can all get there; we just have to work on it and follow our heart that flies with the eagle and sees from its perspective. The brain is freaking out with the insects. (nothing against insects, I love them too)

CHAPTER 9

Listen

LISTENING. THIS IS THE MOST needed skill and one of the least taught. Listening requires the work of both parties. Most people listen just go get their say in and have already made up their mind on what they're going to say next. They are not really listening at all. Thus, you are not having a real conversation at all. Real listening means also listening to what's underneath the words, the type of words being used or repeated, and the body language of the person speaking.

In many native American cultures, a talking stick is used. When a talking stick is used, it's there to remind the listener that they are not listening to respond, to judge, to fix, cure, or heal the other person. They are listening to understand where the person is coming from, what is in their heart.

In improv we listen so carefully. We pull out anything we can use in our characters filter. We listen for anything out of the ordinary in the logic of the other performer so we can play with whatever comes out of that break in logic. We listen for volume to feel the confidence or status of the character. We listen to remember because all the information we gain is used to build upon, to "yes and", to heighten, and to call back again. We are master recyclers and justifiers. Since we are creating a scene together, each line of dialogue providing new information is crucial. We listen so we do not miss important information that tells us who we are to each other or what we want from each other.

If we treated every conversation the same, with intense attention, we would all feel heard and valued. Improvers are taught to be in honest reaction to what they hear. What if we did that in the real world? In our current social construct, most people would lose their jobs. For

instance, say a boss walks in and charges two employees with the task of going thru everyone's desks and determining what supplies came from the supply closet and what was brought from home. Anyone using a pen from anywhere but the company, would be fired. In the real world, you'd hide your feelings and probably carry out the order so you could keep your job and therefor provide for your family (but lie and say you found all company pens to protect your fellow employees from your crazypants boss). But in improv we give honest reactions like this: "Uh, Chet, that's insane, and probably against a ton of HR guidelines, not to mention a huge waste of time!"

Sadly, in the traditional world we cannot have such honest reactions. We listen so we can come back and be right or have a similar story or some other slightly competitive reason. It's great practice to really listen to understand. Especially with kids. They feel so unheard and it takes so much patience sometimes to listen, but it's well worth it and you may learn some things you didn't know about the people you thought you knew best. Asking questions in improv is not a good thing, unless it gives information. For example: "Does a restraining order mean nothing to you?" It's a question but it's loaded with emotional information and relationship. Asking questions in real life is a way to really be engaged in a conversation and improve your listening skills. When I spoke earlier about people caring about how they feel around you, learning to listen is one of the greatest skills you can have as a friend, parent, or good partner.

In our current US political situation, we have clearly forgotten how to listen to each other. We have forgotten how to listen and share our deeper selves with one another. This is tragic! If we take care of ourselves by being authentic, learning to listen, and reflect the authenticity of the people we interact with, we will have a truly awesome world to live in!

CCT Level 2 class dance battle

CHAPTER 10

Make Bold Choices

PEOPLE ARE SO AFRAID OF making choices. The thing to remember is that you can think all day, do flow charts and cost/benefit analysis, and it won't do you any good in the end. If you have two choices, let's say two partners, and if you date this person, then this could happen. If you date this other person, this different thing could happen. The thing with choosing is that whichever path you take, you will get someplace new, something will happen. SEE SAYING YES.

You can always make another choice once you get where choice A or B leads you. We get so afraid of choices. When you remember that there is no failure, only opportunities to be more creative, then there is no reason to fear making a choice. Do not judge yourself or care what others may think. Don't worry about what will happen in the future or base your decision on things that happened in the past. Make a choice in the moment. You will have an inspired decision, that comes from the heart.

There is something that happens to improvers that I call "the secret door dilemma". They will construct something imaginary like a secret door, tunnel, box, or something that needs to be opened, and they will stall so that they don't have to open it because they don't know what's on the other side. Which is hysterical because they made up the situation where this choice needed to be made. You know what is behind that door, or in that box? Possibility. It is whatever we create. We created circumstance of needing to make a choice in the first place just like we will create what happens after. Choice is just a way of reminding yourself that you are not stagnant and that no matter what decision you make, you are in charge of the magic created on the other side of it. Open that door and walk courageously through it. Who knows what you will find!

There is no winning.

Improvisers have said to me, "I didn't go out because I didn't have anything". I say, "That's exactly how I want you to go out in front of that audience, with nothing!"

We came into this world with nothing and look at all the stuff you have now. You have material positions, experiences, scars, a credit score, memories, relationships, all sorts of stuff. And you got it all. You don't need anything to do a good scene but to be present, listen, react, listen (identify the pattern), heighten, and so on.

There is no winning at a scene, and there is no winning at life. Both are made up moment by moment so there is no end outcome that you know you must reach. The key is to enjoy the flow between you and your co-creator (be that your family or your God) and just be totally there. Like there is no other place on earth and no other reality than the one you are creating together in a vacuum of time and space. And when that scene is over, let it go, and listen for the next one, grateful for whatever it has to teach you.

Our entire purpose is to co-create life. Just like an improvised scene, there is no arriving, no certain destination or achievement that must be reached. It's the process of creating that matters. If there was a pattern we could apply to improv and repeat it perfectly every time for a perfect scene, most of us would have walked away years ago. We would have mastered it and left. Art can't be mastered, nor can life. Improv is a living thing. Energy being created on the spot; emotions being called forth from the depths of the cast and audience's experience. It's a form of magic that allows everyone in the room to understand intellectually and emotionally the same thing at the same time with absolutely no idea how we got there or where we are going next. It's a thrilling ride for all involved. Life should be just as inspired as all we have to do here, is to BE. What to be means to you may be different from me, but I chose to be in joy every second I can.

We bring into our lives these critical points where we must make difficult choices. We created that out of our need to create a more fulfilling life, or to move forward in some way. It's a creative, artistic endeavor to make new choices for our lives, but we agonize over it instead of celebrating the opportunity to find a new way. We are afraid of creating. When no matter what, life will go on. We will learn, grow, and experience new things no matter what choice we make, unless we make no choice at all. If that happens, rest assured, your heart will make you crazy until you do. It's your heart that usually brings you to these decision-making plateaus in the first place. Trust it.

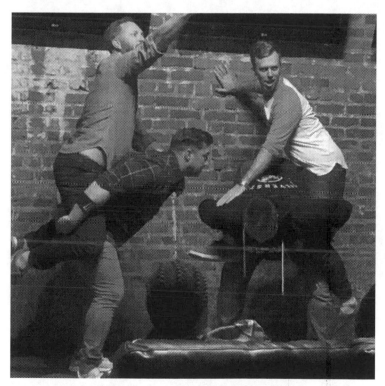

Off the Cuff team playing chicken during
Charlotte Comedy Theater show
From left to right: Jason Spooner, Derek Voorhees,
Eric McCrickard, Caleb Voorhees

CHAPTER 11

Letting Go of Ego

I THINK PEOPLE MISUNDERSTAND THE concept of Ego. They think it has to do with one being full of oneself. When it's actually a lens through which you filter input to match what you already believe to be true about yourself. To me, ego is the opposite. It's the filter in your head that tells you that you are not good enough. It likes to drag all sorts of things through that filter to prove that whatever you think is bad about yourself, is overwhelmingly true. Now people who think little of themselves often overcompensate and act like we have it all together. Which no one does btw. Ego is part of our psychological makeup, and as much as I'd like to have it extracted, it can serve its purposes. For the purposes of improv, there is not room for anyone on stage who thinks they, or anything they have to offer, is better than anyone else's.

Trying to out funny someone, take their scene, steam rolling, and denying someone's offer, are some of the least productive things an improviser can do. Mostly because it's selfish and no one trusts a selfish player. Therefore, they won't make it long on stage. At CCT, I cut that crap out in level one. I've heard people at festivals complain about ego driven people on their cast and I wonder how they got there. I don't care how talented you are, if you are not a team player, you are not a performance improviser. If the improv training program really focuses on the team dynamic up front, then that usually goes away. After all, trying to prove one's self at the expense of others is a fear reaction. If there is no fear, those behaviors are not needed and tend to go away.

Honor the creative process, not just the end result.

In life, we often tend to use the same manipulations to control others because we feel so out of control. Steam rolling is another form of

bullying. Denying is a way crushing someone's creative force, their ideas, their imagination, their dreams. It devaluates the most sacred part of that person. Something we often do a parents, partners, and teachers without even realizing it. We forget that any creation is creation, and judge things too harshly instead of honoring the creative process itself, not just the end outcome of it. We often crush others hopes and dreams by being "realistic" or playing "devils' advocate". I can't stand that term because I'm quite sure negativity and darkness need no help or advocacy, it's everywhere. It's "yes and" and creative freedom that needs advocacy. And being realistic did not get us airplanes, or space travel, or cell phones, or Star Wars! What is real is all perception anyway.

So, encourage the musings of children. Remember how fun it was to play and explore? Instead of stopping others, we should jump in with a big YES and enjoy the ride! We have forgotten how to play. That is why improv is such an important art. It is the one place where adults are encouraged to just play, (besides sports and they have been monetized and have a result to win). Lots of people compete just to prove to their ego that they are not losers, which no one else was really thinking. We have our own insecurities to battle.

The way ego can work for you is that ego knows what you are sensitive to, even if you don't. For instance, if someone walked up to me and called me a bigot, I'd laugh. Whatever. I'm not upset because my ego had nothing to say about it. Nothing in me, even in the far recesses of my insecurity, can you find an association with bigot. Now if someone called me a bad mother, I'm going to have an emotional reaction to that. My ego is going to jump up and throw that filter in there and I'm going to get pissed. I would be pissed because I was devaluated on a level that I have a filter in place for. Honestly, most parents would react to that. We are in no way perfect and should always wonder if we are doing a good job. So, when something happens and I feel myself emotionally bowing up, I really look at it and see what my belief systems are on that topic. Because it's not about what the other person said or did, it's about me believing something negative about myself that needs to be fixed from within.

If someone wants to believe I'm a monster, I can't change that. But if I believe I'm a monster, I most certainly can change that and should. If I believe that, then that's how I will behave and that is not what I want to be. Some people don't know they have a choice. They believe what they have been told about themselves, even if it was in a small moment of time, it became their label, and they hold on to it like a prison. I use my ego as a tool to see where I still have work to do on myself. When we think of ego I go back to thinking of filters. Ego is a huge filtering machine in our brain and until we change those filters, watching our self-talk and changing negative stories we have created, our ego will continue to have its way with us.

Follow the fun!

So many situations in improv and life are intuitive calls. I can't say always do this or never do that. Rules are slippery and even as a veteran improviser, scenes change and morph so fast, you just have to go where it feels good. This is what we call following the fun. Sometimes people will sit back when they felt an urge to do something because they could not decide what to do. I always encourage people to do what seems like the most fun. What makes you giddy and starts moving your body before your mind has caught up? Fun is what it is all about! If you have a decision, what makes you feel good thinking about it? What is empowering and a little risky and a little scary? Challenge yourself and do that.

We don't have to earn joy; but we have to honor it as being a crucial part of our human experience.

In a particularly difficult time in my life, I was taking care of so many people and completely overwhelmed. I went to a concert. Standing in the pouring rain, dancing and singing my heart out, I was joyful. I was aware of being so filled with joy that I realized I forgot how good it felt, and wondered, what the hell am I doing if I'm not doing things that make me feel like this! Why am I here if not to experience this as much as possible!

Keli Semelsberger

After that weekend I started making dramatic changes to my life to tidy up the things that were causing great stress in my life. I broke up an emotionally abusive relationship. I moved my aunt with dementia into a home that could care for her better than I could. I moved back home and focused more on my art and spiritual journey. It was a slow process to do all of that, but my heart knew that the way I was living was not for me. I was so unhappy that I was not helping anyone else by staying in that life. As co-creator of my story, my life, I didn't like what I was reading. Now, joy is my pursuit. I still have to do a bunch of stuff I don't like to do, but I find a way to be grateful and joyful even in those moments. And it works! I'm a much happier person. That was 7 years ago, and during that time I have also quit drinking, then quit smoking, changed my diet, and so much more that seemed to be a natural consequence of giving myself permission to be happy. I had to realize that I deserved it. I did not have to earn it, I just had to create it!

CHAPTER 12

Magic medicine

I HAVE ALREADY TALKED ABOUT the tenants of improv work. How when practiced, they can take a room full of strangers and make them a tribe. There are so many benefits to this work but one of them is the magic. For example: 'the group mind'. The group mind where two or more improvisers will know something at the same moment without any discussion. That's amazing! In spiritual circles, it's tapping into the higher consciousness where we are all linked, have access to the same eternal information, and can connect with all beings of all times.

In the "normal" world, *real* is usually what can be sensed with the 5 senses: taste, touch, sight, hearing, or smelling. When we talk about having a sixth sense, we mean people being able to sense things that we can't sense with the other 5 senses. Like when I get spiritual messages, they are like audio or visual downloads, or they can be a feeling in my body, or an emotion I pick up from someone or something. That's using my sixth sense or however many there may be. Everyone has them. Some are more attuned to them than others, and some of us just ignore them as being our imagination. But our imagination is connected to our higher consciousness and that is connected to all conscienceless, and therefore has validity anyway.

I will tell you that what we pick up with our sixth sense is very real. If it has measurable results, then it is real, right? I have journeyed for people who are geographically far away from me, like a client I had recently stationed in Japan. I went into ceremony, and allowed the images to come and go, and the feelings I got to register. I wrote them all down as soon as I was done. It is not for me to interpret them; I just e-mailed her what I experienced. In this instance, I saw her sitting at a desk that was not against the wall, but with one end against the wall, with the desk separating the room. I saw her looking at a black computer

and writing like she was studying. I saw a white wolf and many other images. When I journey in the middle plane, the here and now, it can still be anywhere in time but it's on this plane of existence. I basically hook up with her conscienceless, her guides, and ask for information.

I also did a healing after the journey per her request. When she got back to me, she was blown away. The description of her at the desk was dead on and exactly what she was doing, sitting at her desk and working on a test. I linked into exactly where she was. I don't know how, I just go and let Spirit do the work. The white wolf is a tattoo she has on her wrist, that I knew nothing about, and so many other images were snagged right out of her life. The reason I believe Spirit gives such clear examples is to let both of us know that I was indeed connected to her, and that the messages were for her.

I have been journeying for years and sometimes it's easy to wonder if you are making this stuff up. But I have also seen things in journeys that I didn't want to see. I wanted to change the image or move on, and it would not change or move. Which lets me know it's not my imagination because I can change that instantly. I've done one for my daughter where I basically pulled names and images out of a book she was reading at the time. These are little anchors to let me know I was where I needed to be.

When I did the healing for the girl in Japan, she said that during it, she got up, went to the bathroom, and cried uncontrollably like she had not cried in years… then it just stopped, and she felt light and balanced and amazing. This was at the time that I did the healing part of the journey for her. So, did I just make up some extremely accurate stuff out of all the stuff I could make up in the world? The collective consciousness is real.

Let me put this back in improv terms. I do this in my classes to show the power and magic of object work. If I hold my hand across my chest and the other one up, as if I were holding a baby, then I patted the air, leaving room for a baby to exist on my shoulder, and I coo to the

made-up baby… my students will come to think of that space in my hands as a baby and have an emotional connection to it. If I throw my hands up in the air as if I were launching the imaginary baby up to the ceiling without any warning, the class will gasp. Involuntarily, they will gasp and watch the ceiling. They know the baby is not real. They will look at me and look back up and back to me. After doing this, I like to start doing another imaginary task like washing dishes while the "baby" is still up in the air. Tension builds, the students can watch me wash dishes, but they are completely distracted by the fact that my fake baby is still up there someplace.

They just can't be okay, until I step back a minute later and act like I'm catching the baby. The whole class is relieved and let out audible sighs. If I stepped back and did not catch the imaginary baby, if I missed, they would never trust me again. I'm not kidding. Even though they could rationalize this was an experiment for me to show them the power of object work. Even though the event was not real, they would subconsciously decide that I am not to be trusted. After all, who throws a baby up and lets if fall to the ground!

It's not logical, we know it was just air, but I created something that the class was emotionally attached to. Part of them believed it to be real, (suspended disbelief) so they are invested in its outcome. If I had a heart monitor on them when I do this imaginary thing, not even a real image, you would get measurable results, even with a pretend baby. That's how hard wired we are.

If I make the baby real to me, it becomes real for others. That's how easily we can define our own reality and make it real for others. Even though what I did was "not real", it had emotional, psychological, and physical results in my class. That makes it real, as these results are measurable. Boom.

Side note – (I wrote most of his prior to 2020 before fake news and different realities became common place. At this point there was not a concerted effort to divide our country with all out incorrect data.

But it's the same premise, the same magic, used to distort and control people by our political machine can be used for good, like in improv or spiritual healing, but it can also be used for nefarious purposes as well.)

If I walked around acting like a victim, someone will pick up on that and gladly help make that more of a substantial reality for me. That's why some people (point to self) tend to attract the same type of people. What we perceive to be true, we give emotional significance and have emotional and physical reactions to. If I can emotionally affect a stranger by pretending to throw a fake baby, that means I could also affect them in a positive way by behaving in some other fashion.

We are magic!

As I proved in my improv baby experiment, we can affect each other in very concrete ways without even saying a word. We can heal or hurt each other. We can touch the heart of another person with just making eye contact and smiling, and we can tap into the consciousness of all beings and heal wounds for all by healing ourselves.

In theater, we often say "fake it till you make it", but if you speak, act, and embody something being true, it does become true. Good or bad. If I know that I cannot fail, if all I do will work out one way or the other for the greater good, then it will. If I believe it, the universe delivers it, and others believe it too. If I can affect my audience by playing with an imaginary hamster on stage, then eating it, and having everyone gagging while I do it, then for that moment, it was real. It affected them. That is the power of suggestion. And it's great to use in a comedy show. It's wonderful to know that for an hour and a half our audience will forget about their bills that are due, or their angry boss, or their lack luster marriage. For that time, while we play and make believe and get ridiculous, they get to be free… and so do we.

It's the art form that does most of the work. Just like when I use medicine drums, I go where the drum tells me. It is what adjusts the vibrations. When I journey, I let the directions, ancestors, angels, and

guides take me. In improv, I listen and react from my heart. I am inspired by what my playmates are doing so that we can create the magical healing powers of laughter. It's great to know that all I must do is say "YES, AND" with passion, and improv, my medicine tool, will change lives. After all, Improv is called **Divine Play**!

That in and of itself, is magic. We are all improvising our lives every moment. So, if we applied the tenants of improv by reacting honestly in every moment, listening to others to understand where they are coming from, then building upon their unique contribution, we would all be co-creating a totally different story of our world and it would be AMAZING! That is the kind of magic medicine that improv brings to the word, and a way of being that I hope everyone gets to experience.

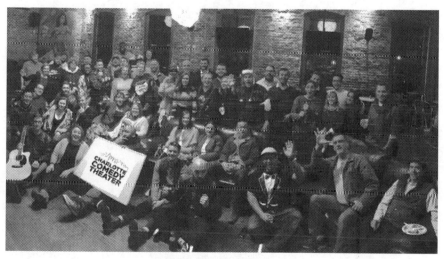

Charlotte Comedy Theater
2018 Christmas Party

EPILOGUE

FOR THE MORE SPIRITUALLY INQUISITIVE:

In the time before doctors and drugs, when our ancestors lived primitively, there were only Shamans or wise elders who used healing touch, songs, drumming, prayers, and plant medicine. In every ancient culture, there were healers. Had their practices not worked, we would not be here today. I passionately believe it is time to go back to the ancient ways. The ancient practices handed down from generation to generation were all but destroyed by religions, controlling governments, and witch hunts. We are now in a time of "remembering". During this time in human history, our ancient ways are coming back to us so that we can heal the world, and all the beings here.

We are all healers. It was a gift given to us, but our lineage and teachings were forgotten in time. However, we can all heal ourselves by tapping into universal energy, God source, light energy, whatever you want to call it. But it is as real as you live and breathe. It is a part of all living beings, and it is magical once you know how to honor it, and work with it.

ACKNOWLEDGEMENTS

I WAS SO PUSHED BY Spirit to write this book, and having zero experience in writing, it was such a blessing to have such a great Earthly group of people to help me bring it to life. Colby Semelsberger, my beautiful and courageous daughter who dealt with my horrendous spelling and questionable parenting style. Jonathan Pitts has been a great mentor and especially when Charlotte Comedy Theater was still a fledgling group of improvisers some 20 years ago, and a dear friend who didn't flinch when I said I talk to trees, and in fact, sent me photos of amazing tree people during his travels across the world. I have to thank all of my improv teachers; the incomparable Susan Messing and Charna Halpern who are still my greatest mentors, Miles Stroth, Joe Bill, Mick Napier, Del Close, Amy Poehler to name a few. I can't thank the members of the Team Know Direction enough; Stuart Ranson, Brian Dunn, Kate Lee, Jim Sharp, Jillian Jester, Bob Kulhan, & the late Steven Wright for creating the most beautiful first team experience at IO a girl could ask for, and for being my friends to this day. I could never name all whom I learned from and with but have to shout out to the cast of Guilty Party, Mystery Machine, Monster Island, The Lost Yetis, The Tribe, The Family, and Upright Citizens Brigade. I am so grateful for IO, the Annoyance Theater, Second City, and Comedy Sportz Chicago for giving me a place to call home, dealing with my obnoxious behavior, rewarding said behavior, and for helping me find my true calling and my life's work. To Frank Janisch who was my first improv buddy ever, and will forever be "the Cannon".

I am so humbled by the cast and students at Charlotte Comedy Theater! I showed up in Charlotte and was given a place to teach, to play, and bring my wild Chicago ideas to a completely uncharted territory. The people of Charlotte embraced improv and I thank everyone so much for trusting me, trusting the process and the art. I have been able to bear witness to this artform changing so many lives from class one to now, 20 years later. Besides my children, is my greatest gift in this life.

In particular I want to thank the CCT members who have had my back for years upon years of shows: Brian Briscoe, Jack Davis, Drea Leonetti, Jason Spooner, Eric McCrickard, Austen DiPalma, Will Spann, James Walker, Tracy & Red Davies, PJ Kelly, Jack Davis, Andy Smith, Derek Voorhees, Cale Evans, Karla Dingle & Ted Delorne and the Late Colby Davis whom was my wayward son, incredibly talented, and very much missed. I have had so many brilliant performers on my stage and in my classes over the last 20 years, so I could never name every one of them, but each one has left an indelible print on my soul and I am so grateful to have been part of their life's journey. Each one has taught me as much about improv and life as I have taught them.

I also want to thank everyone who gave their time, energy and financial support to re-open CCT after Covid, it was a true community effort!

I want to thank my great spiritual teachers as well, I have been so honored to learn from masters, shaman, medicine men and woman from all over the world that I want to send great love for their teachings and guidance on matters that most people would put me away for inquiring about, but these mystical warriors found commonplace and again, gave me a home and a sense of belonging. The Otter Dance/ fire Dance community in NC and TN have become a larger family for me and my kids whom I can always call on and can't wait to get dancing with again! I want to thank specifically; Pat Daystar – who taught me how to radiate love, the gifts that come with a TBI and ancient dousing methodologies, Robbie Otterwoman – who taught me Shamanic principals and to how to heal the world through ceremonial dance, Trai Hill – who taught me how to keep sacred fire, the late Sobonfu Some' - who taught me to heal through ritual grieving and forgiveness, Alberto Villoldo – who taught me how to be luminous, Serge Kahill – who taught me the seven principals of Huna and how to keep my bowl of light clear, Kazume Arakaki – who conducted sacred ceremony with me at Kilauea and Mouna Kea, Marianne Williamson – who taught me to walk towards love and away from fear, Mamma Sue Neff – who taught me how to not take life too seriously and to trust my inner guide.

Therese and Ben Burton, that helped me raise my child while I obsessed over improv. I also have to thank my best friends. Sabrina Pratt & Nick Cox who legit make my very soul laugh and I never want to live without you! Crissy Anderson, Dawn Boland, & Bobby Pomeroy who have been a constant source of love, laughter & support.

I want to especially thank my daughter Colby who suffered the brunt of my improv obsession in the early years, and has shown me what real courage is as she tackles what seem like insurmountable issues with her stellar wit and fathomless compassion, (and several curse words). To my son Jake, who is has surprised and delighted me with his hilarious antics since day one, and has overcome so much by maintaining your big heart and incredible sense of humor. I love you beyond words! To my grandkids Lilly and Ben, who make me laugh every day. You guys are my life and why I strive to heal myself and the world, to make it all better for you and our children's children. To my step mother Shirley Bright who taught a feral child how to see the world differently, to have integrity and that the world was as full of love as it was pain. Your love changed my life. To my sister Katherine Telfari, who is a great visual & spoken word artist, to my sister Jessica who loves so easily and abundantly, and to all the Semelsbergers who live up to the hopes and dreams of our ancestors with honor, humor and compassion.

As I do daily, I thank the Ancestors – the ones that came before and the ones yet to be created, I thank the 7 directions, the rooted ones, the four legged, the two legged, the ones that swim and fly and crawl. I thank the elements, I thank the star people, Christ consciousness (love), the in-between world beings, the angels, the guides and the light beings that have been assigned to me by God (seen and unseen), and my soul tribe.

I thank Great Spirit for bringing me such an unexpected and miraculous life. May all our lessons be gentle, let us serve the greater good of all living things with a joyful song in our hearts, and may all be blessed with wisdom, kindness, gratitude, and abundance! Aho mataquiasa.

Learn Improv, change your life!

If you would like to see a CCT show or take a class visit CharlotteComedyTheater.com and please follow us on social media:

https://www.facebook.com/CharlotteComedyTheater
https://www.instagram.com/charlottecomedytheater/
www.vapacenter.com

For studying with me personally as a spiritual mentor, or for corporate teambuilding workshops please contact improvkeli@yahoo.com.

For improv in Chicago check out: www.ioimprov.com, & www.theannoyance.com.

For improv classes in California visit CentralCoastComedy.com or UCB LA.

Fire Dance info: www.otterdance.com, www.centerforpeace.us.

www.otterdance.earth

ABOUT THE AUTHOR

KELI HAS SPENT THE LAST 26 years teaching, directing and performing live improv comedy. She began her improv career learning from the masters in Chicago, and brought the art form to Charlotte in 2001, when she founded the award-winning Charlotte Comedy Theater. She has traveled extensively in her quest to learn different culture's shamanistic healing modalities as a Reiki Master, energy medicine, & metaphysical science practitioner. Keli is also a committed human rights activist, grandmother, Army veteran, white water raft guide and nature lover. She is a founding member, and on the Board of Directors of Charlotte's Visual and Performing Arts Center.

She can usually be found on stage at CCT or doing ceremony near water in some obscure and mysterious location.

Keli Semelsberger

Printed in the United States
by Baker & Taylor Publisher Services